Drawing Light & Shade

UNDERSTANDING CHIAROSCURO

Giovanni Civardi

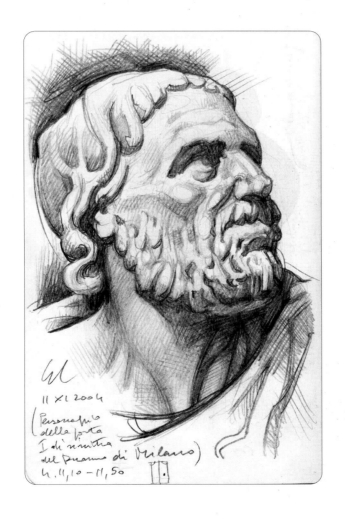

SEARCH PRESS

First published in Great Britain 2006 by Search Press Limited,
Wellwood, North Farm Road, Tunbridge Wells, Kent TN2 3DR

Originally published in Italy by Il Castello Collane Tecniche,
Milano

Translated by Linda Black in association with First Edition
Translations Ltd, Cambridge, UK
Edited by Carey Denton in association with First Edition
Translations Ltd

ISBN 978 1 84448 186 6

The figure drawings reproduced in this book are of
consenting models or informed individuals: any
resemblance to other people is by chance.

INTRODUCTION

Chiaroscuro generally refers to the graduating tones, from light to dark, in a work of art, and the artist's skill in using this technique to represent volume and mood.

Chiaroscuro has been used to suggest form in relation to a light source in the art of many civilisations – although it was unknown to early cultures such as the Ancient Egyptians. It came to the fore in western art, and particularly in Italy, during the 16th century.

Many elements can influence the way in which chiaroscuro is used: the relationship between its own components (light and dark); the relationship with colour; the method of distributing the light and dark elements that characterise the composition and expressive quality of a painting; as well as social and philosophical attitudes. We can see examples of chiaroscuro in many of the works of the great artists: the blazing light and abysmal darkness of Rembrandt's etchings, demonstrating chiaroscuro elements 'of the soul'; a chiaroscuro in which light prevails over dark in the work of Giotto and Michelangelo; a pictorial chiaroscuro in which darkness prevails, but with the dark outlines shaded off, which tends to suggest a lively atmosphere around the volume of the bodies as in Leonardo; a tonal chiaroscuro, in which relations between light and dark are based on the quantity and quality of the light and shade that the colours absorb in themselves in the work of Titian and Giorgione; a luminous chiaroscuro, in which the contrast between the illuminated parts and shadowed parts is violent, intense and unusual as in the work of Caravaggio.

On the pages that follow I have tried to suggest some useful approaches to the complex topic of chiaroscuro by explaining the basic drawing techniques you will need and, especially, by suggesting methods of observation and experimentation. The play of light and shade involves any subject that can be portrayed, not only from a realistic or naturalistic view, but also, and perhaps more importantly today, in representation – in communicating emotions, moods, ideals, dreams, hopes and experiences.

The brightest days are followed by darkness

Thérese de Lisieux

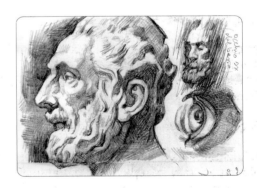

LIGHT AND SHADE

Light is energy emitted from a light source – either natural or artificial: the sun, a flame, a lit lamp, etc. Because of it, we can see objects. Transparent bodies allow light to pass through them in varying degrees; opaque bodies do not allow light rays to pass through them. On opaque bodies, in particular, shadows are produced and they, in turn, can project shadows on to neighbouring surfaces. Very rarely a surface absorbs light completely, more frequently the light is, in varying degrees, reflected and diffused in the surrounding environment.

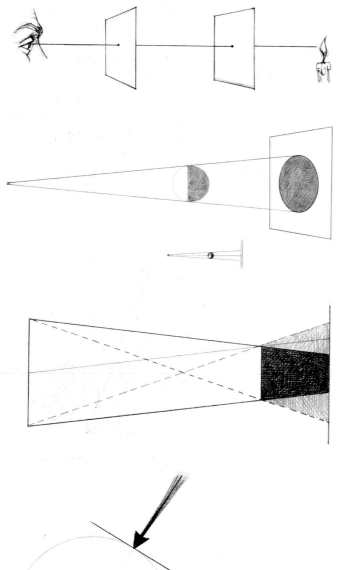

Rectilinear transmission of light and the formation of shadows

Light is transmitted in a straight line. A light ray is a line of light that travels to a given point. Beams of light are all the light rays that cross a given surface.

To demonstrate the linear transmission of light, place a couple of pieces of card, each with a small hole, between your eye and the flame of a candle.

A consequence of the rectilinear transmission of light is the formation of shadows and the way in which they are arranged. A tiny spherical light source produces a cone of light that projects, on a screen in the distance, the shadow of an opaque sphere placed in between.

Point of maximum luminosity on a spherical object

Consider the difference between the sun's rays as they reach Earth at the equator and poles: the intensity is strongest when the light ray is at 90 degrees to the surface on which it falls.

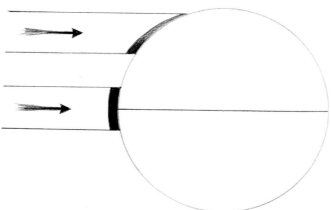

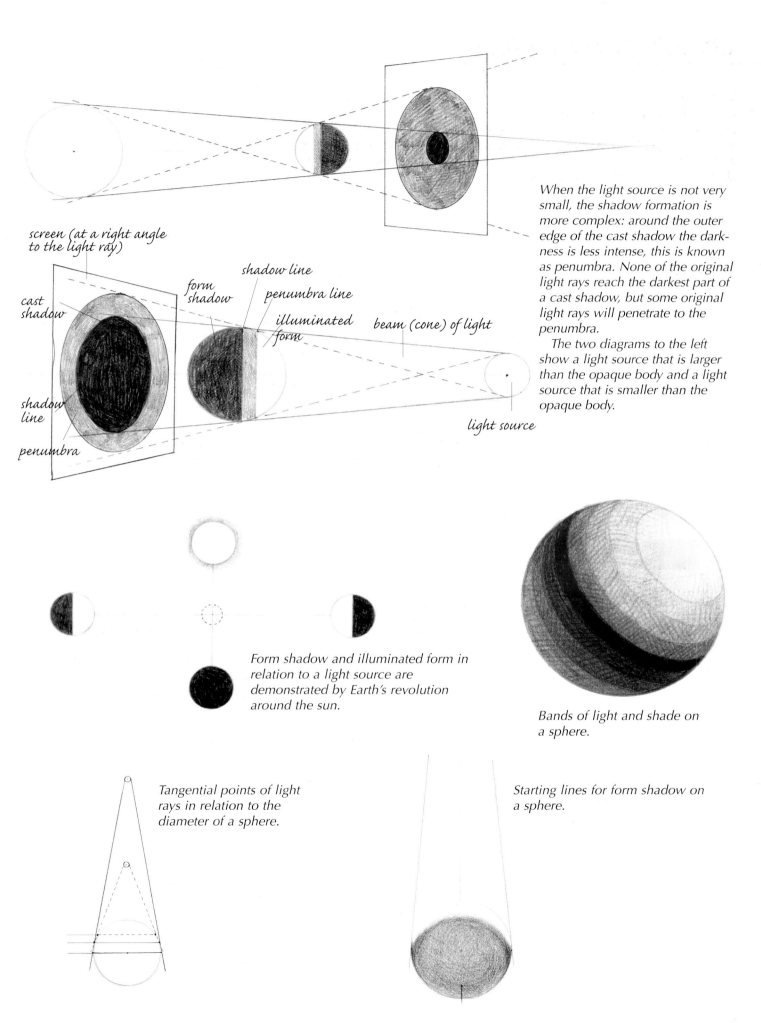

screen (at a right angle to the light ray)

cast shadow

shadow line

penumbra

form shadow

shadow line

penumbra line

illuminated form

beam (cone) of light

light source

When the light source is not very small, the shadow formation is more complex: around the outer edge of the cast shadow the darkness is less intense, this is known as penumbra. None of the original light rays reach the darkest part of a cast shadow, but some original light rays will penetrate to the penumbra.

The two diagrams to the left show a light source that is larger than the opaque body and a light source that is smaller than the opaque body.

Form shadow and illuminated form in relation to a light source are demonstrated by Earth's revolution around the sun.

Bands of light and shade on a sphere.

Tangential points of light rays in relation to the diameter of a sphere.

Starting lines for form shadow on a sphere.

From the circle (outline) to the sphere (volume).

Form shadow and reflected light are, if not essential, at least very useful for suggesting the volume of an object.

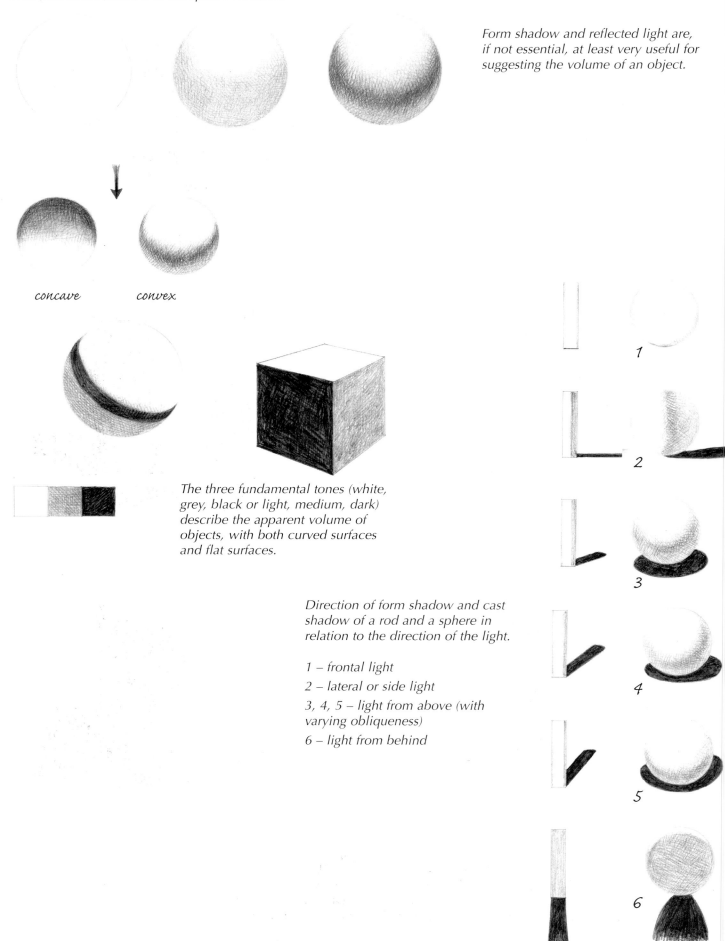

concave convex

The three fundamental tones (white, grey, black or light, medium, dark) describe the apparent volume of objects, with both curved surfaces and flat surfaces.

Direction of form shadow and cast shadow of a rod and a sphere in relation to the direction of the light.

1 – frontal light
2 – lateral or side light
3, 4, 5 – light from above (with varying obliqueness)
6 – light from behind

1

2

3

4

5

6

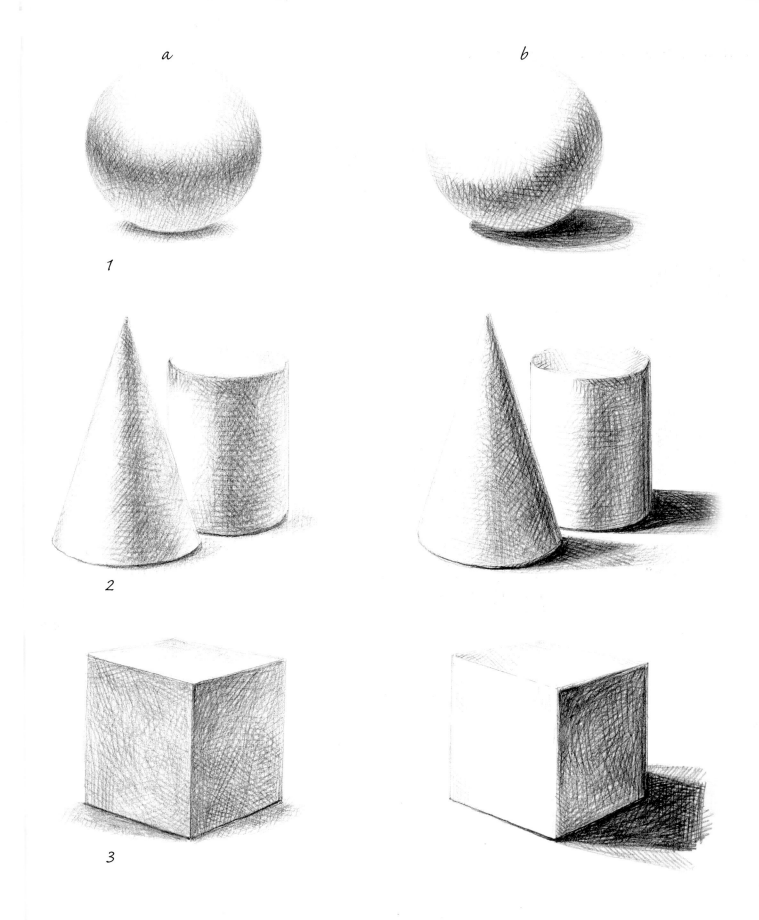

Effects of diffused light (a) and direct light (b) on a spherical shape (1); on cylindrical and conical shapes (2) and on objects with flat sides (3). Diffused light on a cloudy day for example, produces less distinct form shadows and graduated cast shadows. Direct light, from an electric spotlight for example, produces both form and cast shadows that are sharp and intense.

FORM SHADOW AND CAST SHADOW

If light indicates an object's shape, shadows define its volume. Form shadow appears on an object as a result of lighting. Cast shadow is that which the body casts on to other surfaces: neighbouring objects or planes. Cast shadow expresses the relationship between the object and the environment: its development and extension indicate the position of the light source, its nature, its intensity and the way in which the light rays hit the object. Form shadow nearly always contains reflected light, which comes from the environment and is very important for showing the volume of the object. Reflected light never has the same force as direct light, but lightens the form shadow in varying degrees. Consequently, the maximum intensity of this shadow is found along the shadow line, the boundary between the illuminated part of the body and its shadowed part.

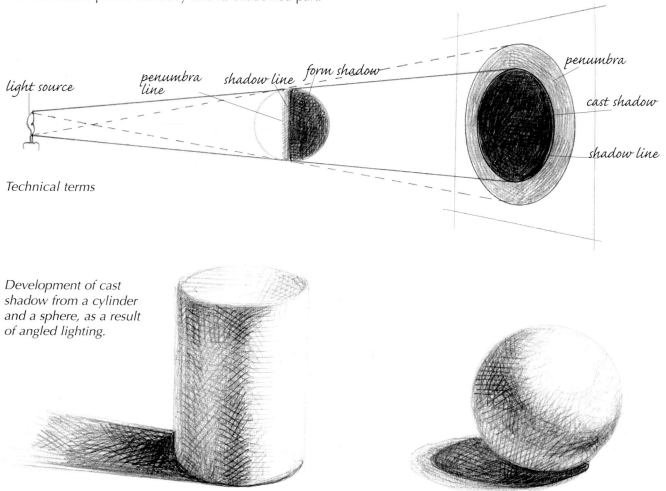

Technical terms

Development of cast shadow from a cylinder and a sphere, as a result of angled lighting.

Types of lighting: form shadow produced by different directions of the light.

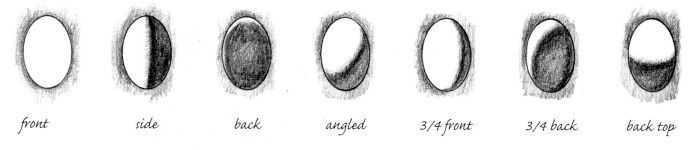

front side back angled 3/4 front 3/4 back back top

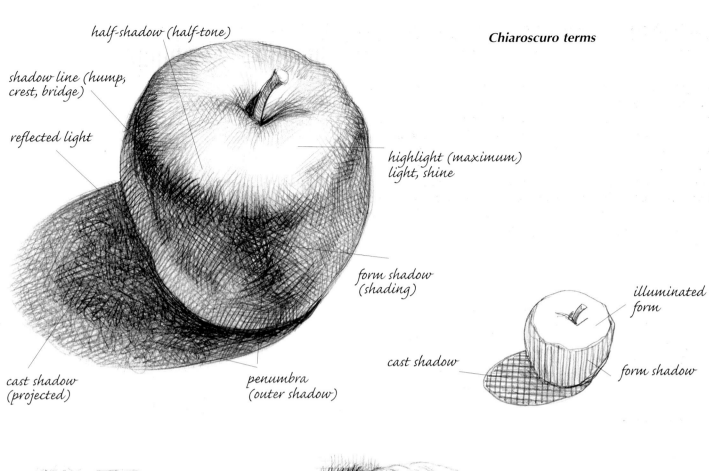

half-shadow (half-tone)

shadow line (hump, crest, bridge)

reflected light

highlight (maximum) light, shine

form shadow (shading)

cast shadow (projected)

penumbra (outer shadow)

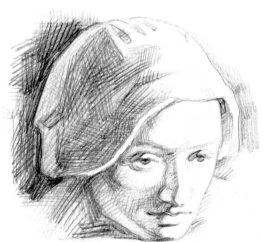

illuminated form

cast shadow

form shadow

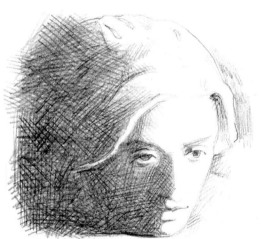

Reflected light is extremely important for depicting volume in drawings and paintings.

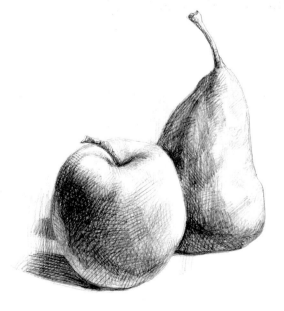

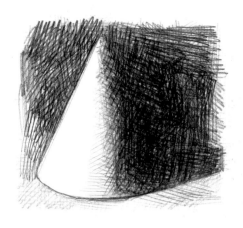
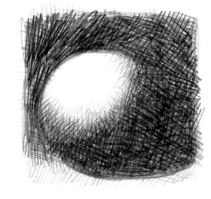

Simple geometric shapes such as a cone, sphere, or cube are ideal for practising the effects of light and shade.

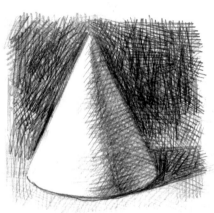
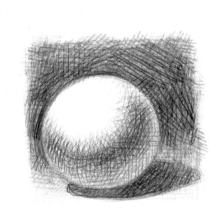

A practical way of estimating the height of a tall object on flat land is to measure its cast shadow and compare it to the length of a shadow cast by a measuring rod.

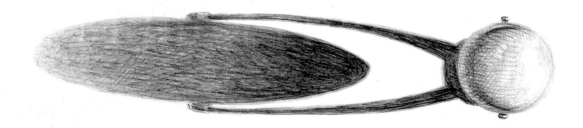

A cast shadow can profoundly alter the shape of the body that produces it.

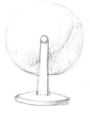
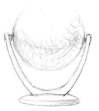

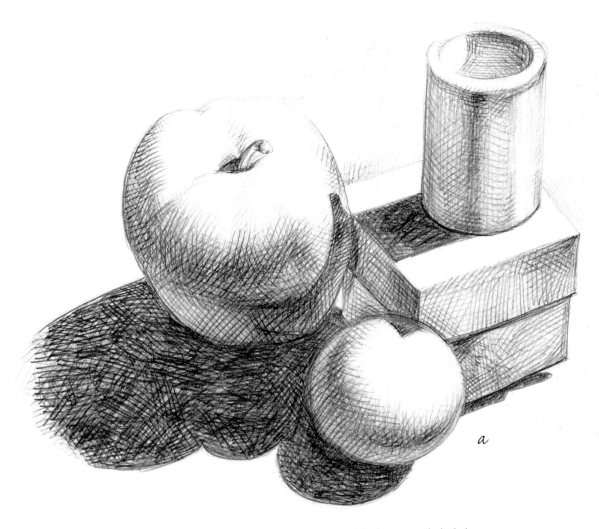

Form and cast shadow on simple objects exposed to direct natural light (a) and slightly diffused light, from a large window (b).

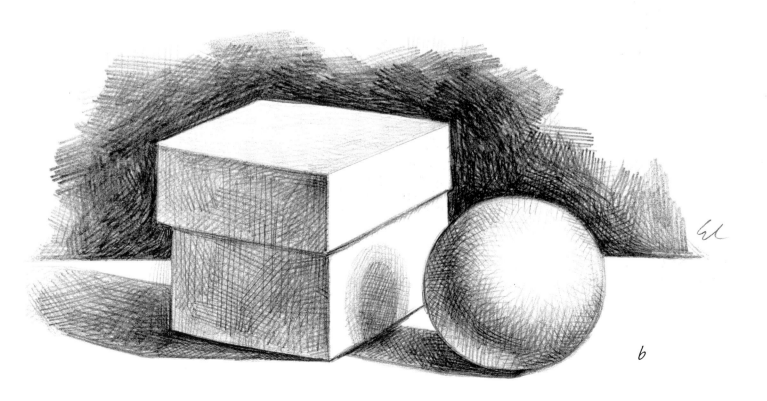

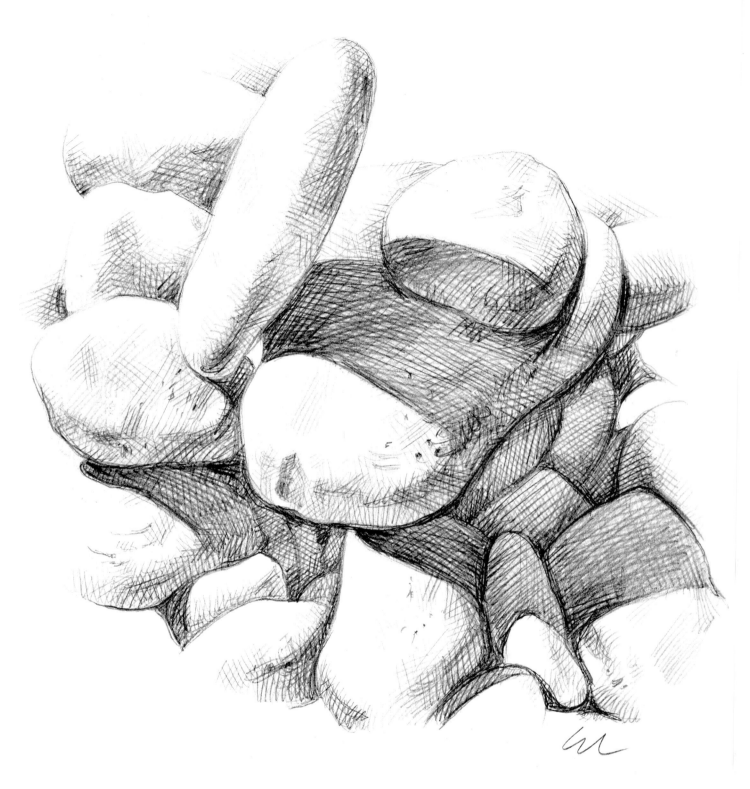

Stones and pebbles are good for studying the development of shadows cast by objects arranged in a complex way and by irregular shapes.

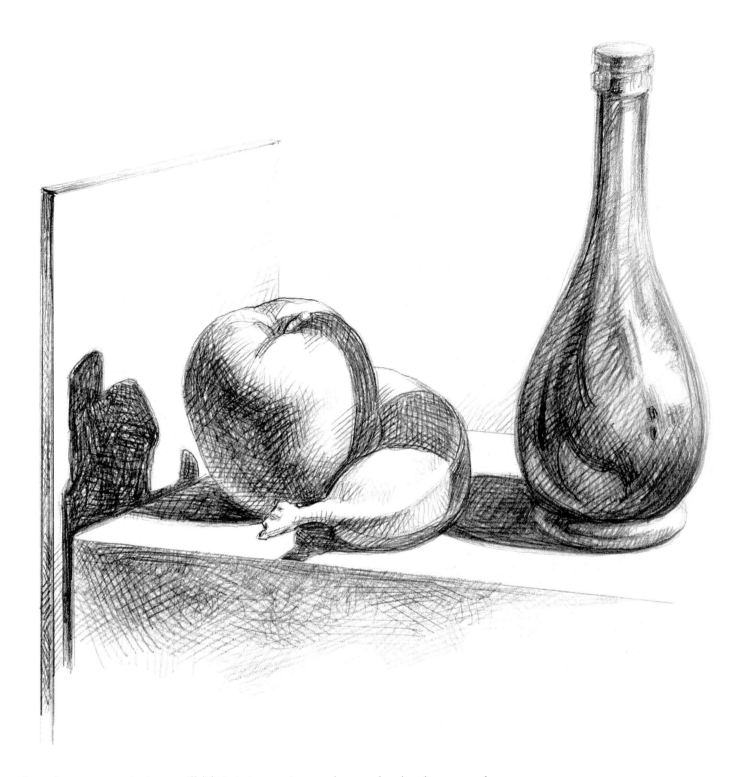

When drawing or painting a still life it is interesting to observe the development of cast shadows, apart from on neighbouring objects, on the surface it is arranged on and the vertical surfaces in the background as well.

PERSPECTIVE AND SHADOW THEORY

'Perspective' is the method of representing objects, landscapes, buildings or figures in order to suggest a sense of volume on a two dimensional surface. In drawings it represents the object just as it appears to the eye of the onlooker. Objects, as a result of lighting, produce shadows on themselves and on adjacent surfaces. The 'shadow theory' considers the objects and shadows in relation to the light source so as to establish, using perspective, the limits of form and particularly cast shadows.

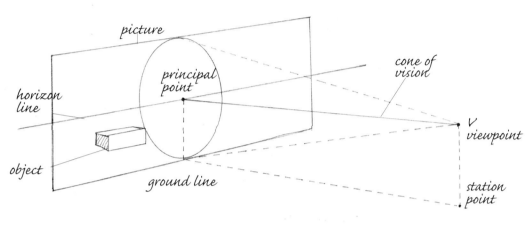

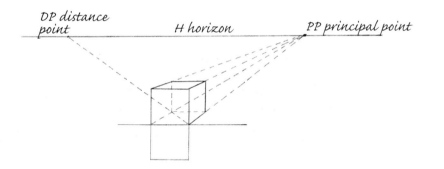

In linear perspective, a sense of depth is created by drawing objects progressively smaller as they go further away from the observer (viewpoint) and making them converge in a point (vanishing point).

Linear perspective is used in two ways: parallel linear perspective, where the object is seen frontally, and angular linear perspective where the object is viewed obliquely.

In parallel perspective the horizontal lines of the sides of a solid cube are arranged in depth lines that converge in a central vanishing point and are organised by distance points positioned on the horizon.

In angular perspective, the horizontal lines of the objects positioned obliquely converge laterally, on the horizon line, in two vanishing points.

In both cases the vertical lines of the objects remain vertical in the drawing.

By varying the level of the viewpoint we obtain different perspectives: from above, from below, etc.

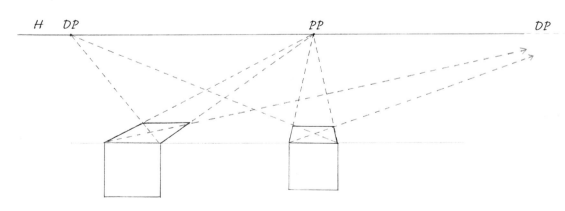

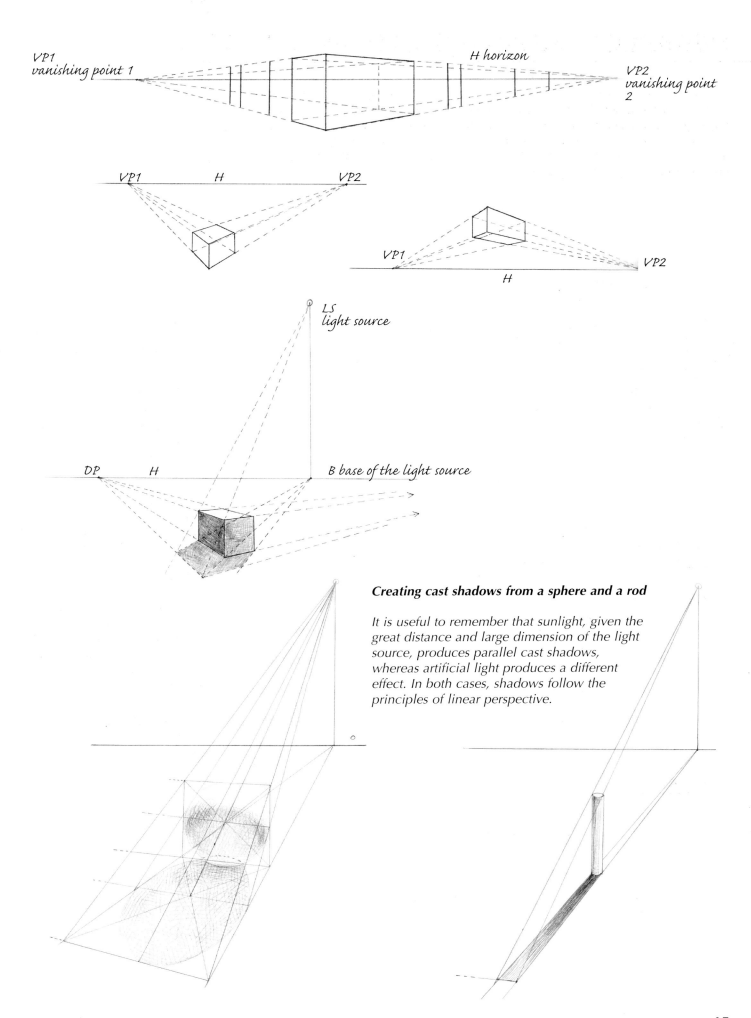

VP1
vanishing point 1

H horizon

VP2
vanishing point 2

VP1 H VP2

VP1

VP2

H

LS
light source

DP H

B base of the light source

Creating cast shadows from a sphere and a rod

It is useful to remember that sunlight, given the great distance and large dimension of the light source, produces parallel cast shadows, whereas artificial light produces a different effect. In both cases, shadows follow the principles of linear perspective.

TONE AND TONAL VALUES

The term 'tone' refers to the intensity of an area; how light or how dark it is, irrespective of its colour. 'Tonal value' is the gradation of a tone in relation to other tones using a scale that ranges from white to black, the extremes of an intermediate series of greys. Tone is influenced by factors such as the intensity of the light in relation to the shadow (if the light is very bright, the shadow is very dark and the intermediate gradations are limited); the relationship with adjacent tonal values; the 'quality' of the light (natural, diffused, etc.); the presence of reflected light.

Tone is also the overall effect of light and shade on a surface, you could say the effects produced by the contrasts between light and dark, by the arrangement of light tones and dark tones or their simplification. All these methods will be mentioned later on and are used to establish tonal structure, a fundamental 'constructive' element of a drawing or painting.

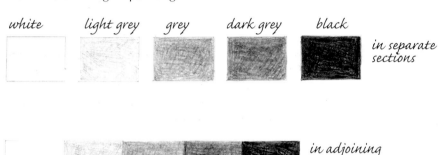

white *light grey* *grey* *dark grey* *black*

in separate sections

in adjoining sections

gradual shading with continuous progression

Simplified scale of five tonalities. Our eye also perceives slight differences between similar tones according to whether they are side by side or slightly apart, surrounded by a dark or light surface, etc. These differences in intensity are mainly noticed along the 'contact' line between tonal areas.

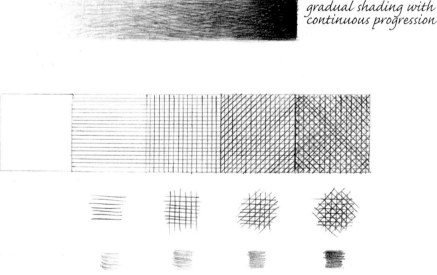

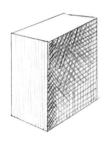

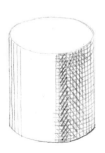

Cross-hatching is a simple technique for showing the various degrees of tonal intensity. Using this method you can progress from the white of the sheet of paper to the most saturated black.

In the sequence of five tones above the white represents maximum light; the light grey, direct light; the grey, diffused or reflected light; the dark grey, shadow; the black, maximum intensity of shadow.

Cross-hatching can 'follow the shape' using strokes that follow the direction of the longest sides or 'contrast the shape' using short strokes that go against the longest sides.

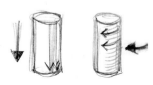

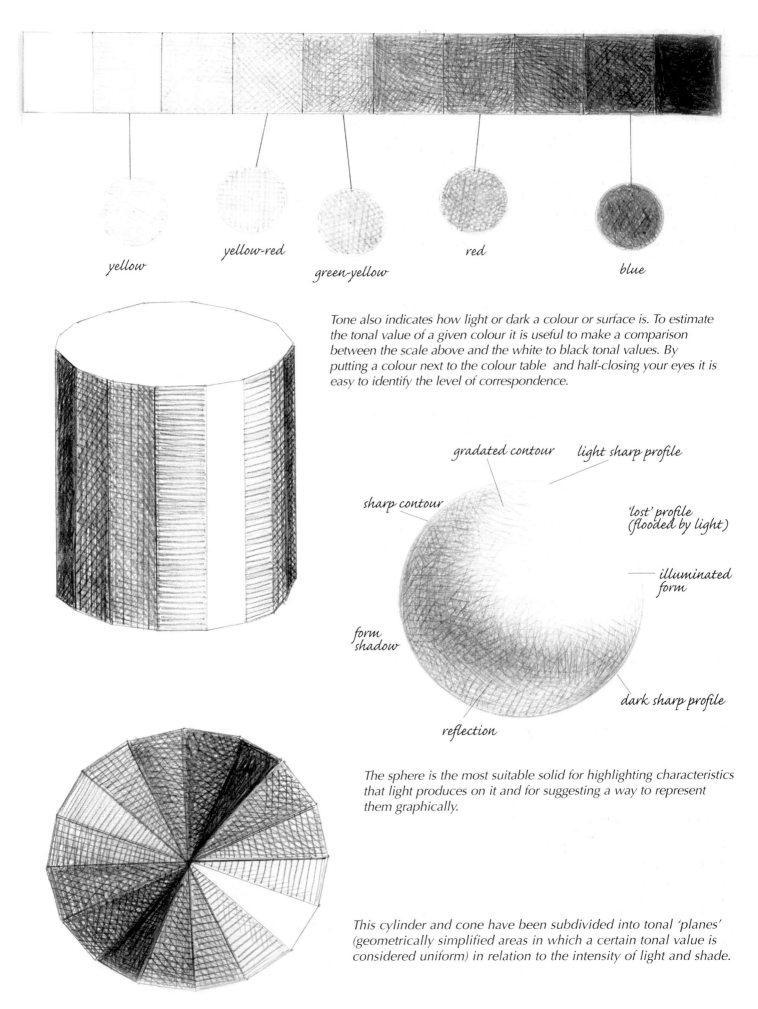

yellow

yellow-red

green-yellow

red

blue

Tone also indicates how light or dark a colour or surface is. To estimate the tonal value of a given colour it is useful to make a comparison between the scale above and the white to black tonal values. By putting a colour next to the colour table and half-closing your eyes it is easy to identify the level of correspondence.

gradated contour

light sharp profile

sharp contour

'lost' profile
(flooded by light)

illuminated
form

form
shadow

dark sharp profile

reflection

The sphere is the most suitable solid for highlighting characteristics that light produces on it and for suggesting a way to represent them graphically.

This cylinder and cone have been subdivided into tonal 'planes' (geometrically simplified areas in which a certain tonal value is considered uniform) in relation to the intensity of light and shade.

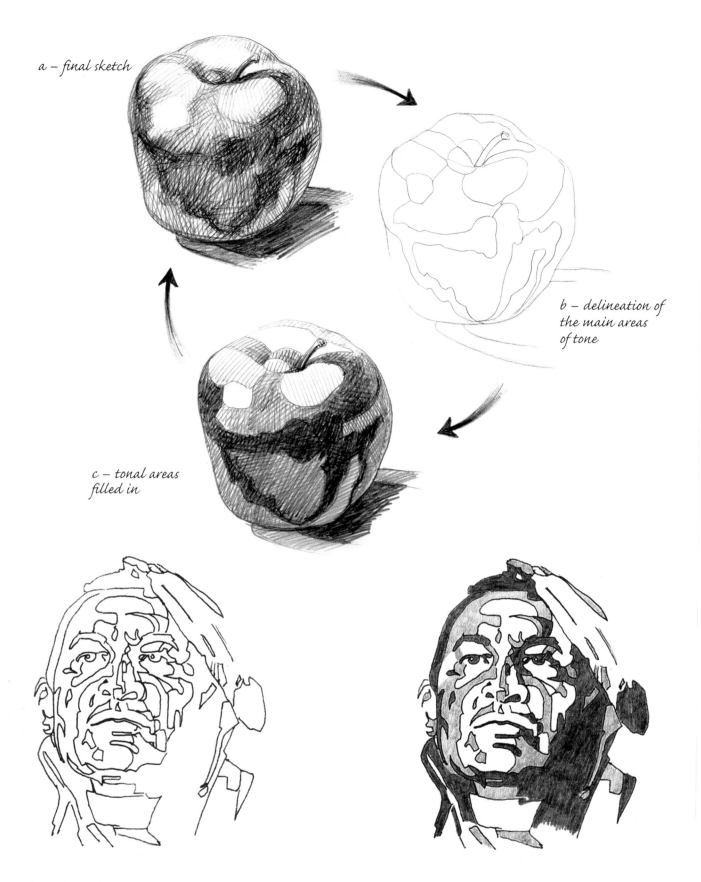

a – final sketch

b – delineation of the main areas of tone

c – tonal areas filled in

Areas of equal tonal intensity. To practise 'seeing' the most appropriate tones for portraying the volume of an object, it can be useful to single out and outline the areas in which the tone appears to have uniform intensity.

In the sketch portraying the apple, for example, I have singled out five important tones (although there are really many more) whilst, in the sketch portraying the face of the Native American, I preferred to delineate the areas relating to just three tonal values: white, grey and black.

Assessing the tonal areas of metal objects is particularly complicated because of the shiny, reflective surface. Yet it is a very profitable exercise in observation.

TONAL SIMPLIFICATION

In chiaroscuro, which is based entirely on the modulation of tones of shade, it is advisable to limit the range of tonal gradations to not more than eight or nine or even fewer if it is possible to do so without impoverishing the means of expression. This gives 'consistency' to the portrayed shape, which may be weakened by over-emphasising the shading.

 Tonal sketches are a good way to practise recognising and simplifying tonalities (see page 47). This is how you can do it: half-close your eyes, single out the darkest areas, assess the most significant 'local' tones, remember the main intermediate tones from among them.

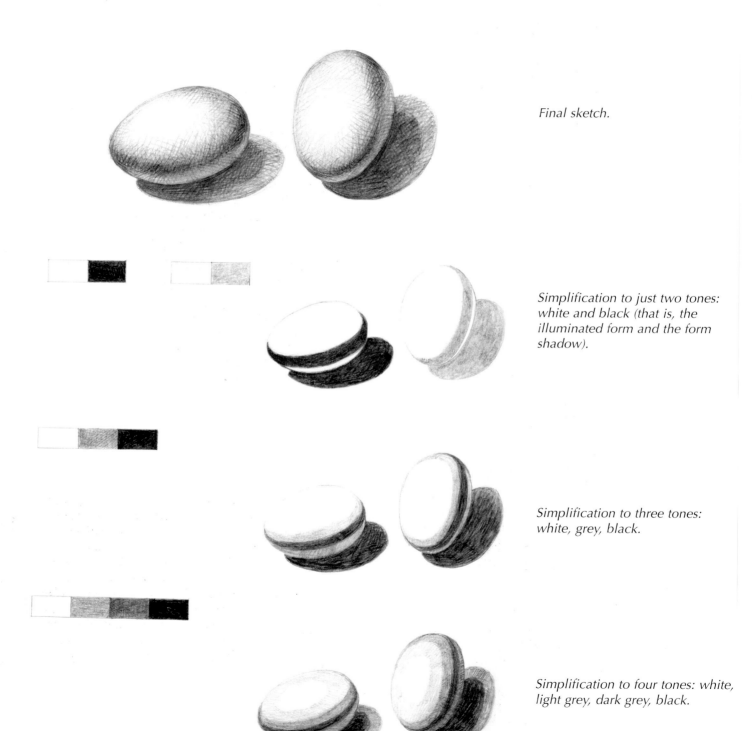

Final sketch.

Simplification to just two tones: white and black (that is, the illuminated form and the form shadow).

Simplification to three tones: white, grey, black.

Simplification to four tones: white, light grey, dark grey, black.

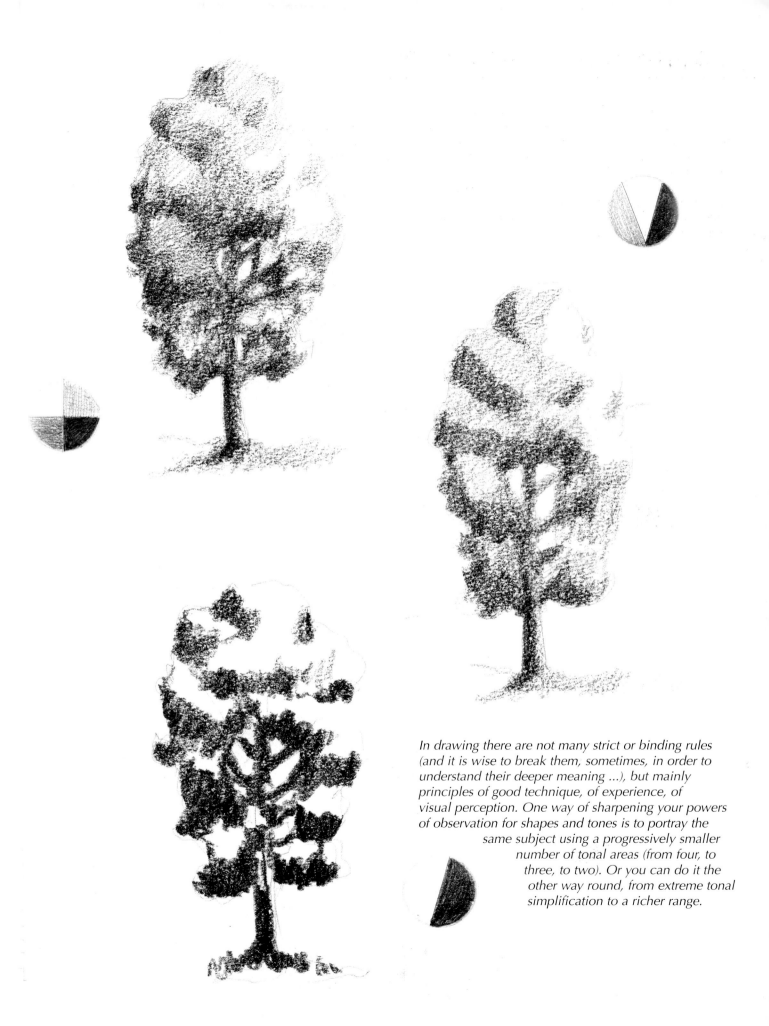

In drawing there are not many strict or binding rules (and it is wise to break them, sometimes, in order to understand their deeper meaning ...), but mainly principles of good technique, of experience, of visual perception. One way of sharpening your powers of observation for shapes and tones is to portray the same subject using a progressively smaller number of tonal areas (from four, to three, to two). Or you can do it the other way round, from extreme tonal simplification to a richer range.

GRADATION OF TONES

Gradating tones are the means by which we produce chiaroscuro. The procedure is sometimes called 'shading' or 'adding value'. It consists in portraying the volume of bodies using tonal variation by observing, recognising and comparing them to the different tonalities we see on the actual object. First establish the range of tones, singling out the area in which the tone appears darkest (for example, black or a certain degree of grey) and that in which it appears lightest (white) and the value of the dominant tone. Then, you can gradate the intermediate tones, assessing the changes between the various tonal planes.

It is possible to introduce 'accents' (the lightest and darkest) at appropriate places, in order to best suggest the volume of the portrayed object with maximum efficacy. Delineation of tonal areas is only used as an observation exercise: in the actual drawing, the tonal changes should appear decisive but gradual, without sharp linear contours. The most intuitive technical procedure for shading is hatching, and some examples of the various ways in which it can be produced are shown on this page.

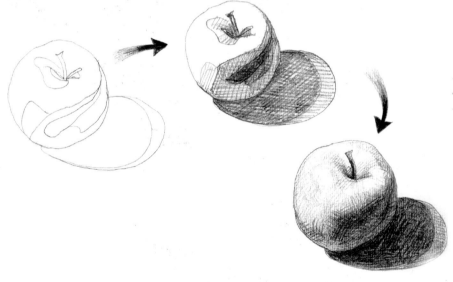

From singling out and filling in the main tonal areas to shading tones in chiaroscuro.

cross-hatching

irregular hatching

parallel hatching

dotting

continuous shading off

casual strokes

circular strokes

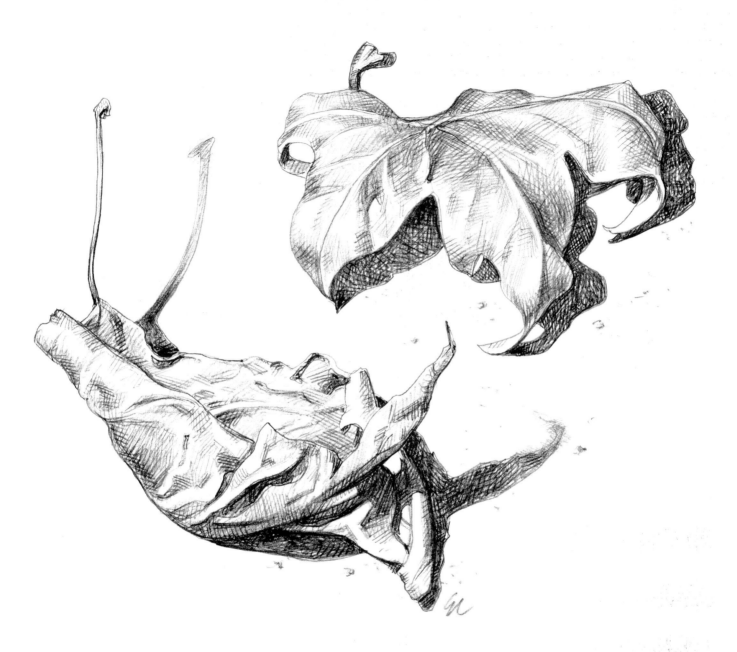

Dry leaves offer good opportunities for studying very fragmented chiaroscuro: small illuminated parts alternate with small shadowed parts, sometimes in unexpected ways, suggesting strange and curious shapes, not only in their form but in the shadows cast on the ground.

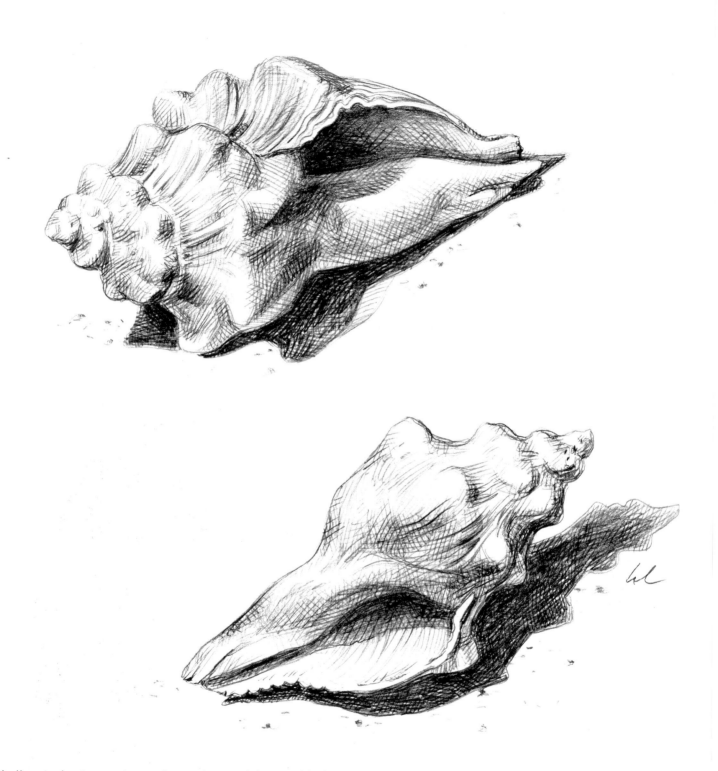

Shells are also interesting and complex models, suitable for studying complicated protrusions, recesses and grooves as well as areas of light and shade. Their surface is smooth and shiny in places: this helps us observe, on the same object, the various ways in which light is reflected as it falls on both rough and smooth surfaces.

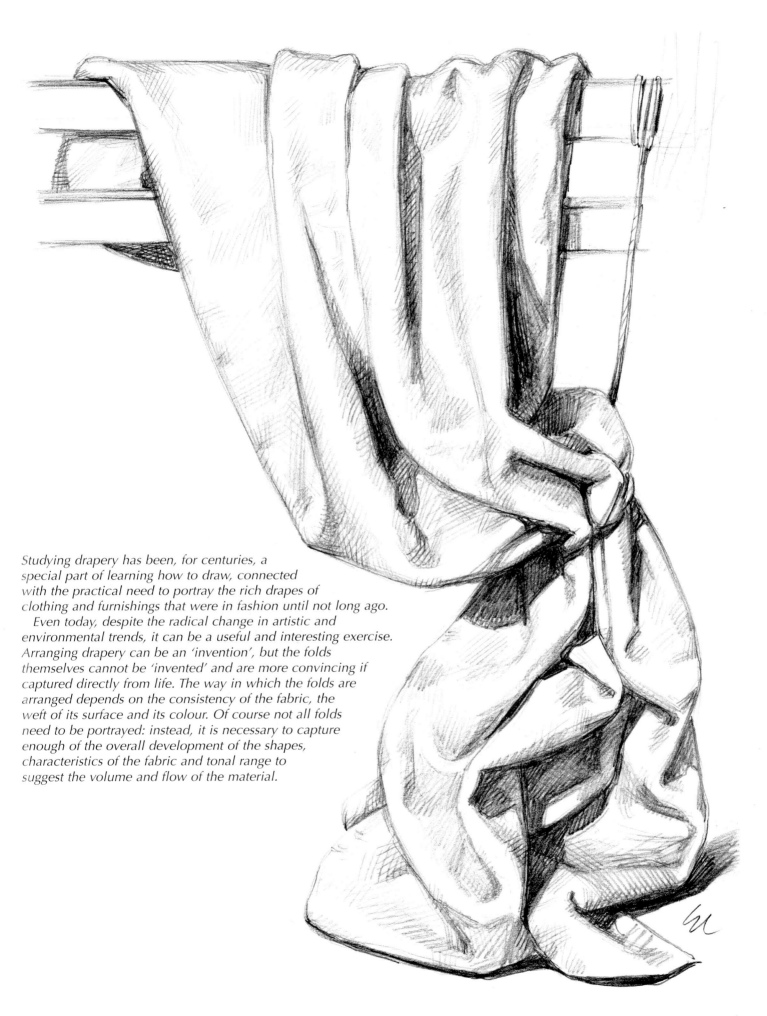

Studying drapery has been, for centuries, a
special part of learning how to draw, connected
with the practical need to portray the rich drapes of
clothing and furnishings that were in fashion until not long ago.
 Even today, despite the radical change in artistic and
environmental trends, it can be a useful and interesting exercise.
Arranging drapery can be an 'invention', but the folds
themselves cannot be 'invented' and are more convincing if
captured directly from life. The way in which the folds are
arranged depends on the consistency of the fabric, the
weft of its surface and its colour. Of course not all folds
need to be portrayed: instead, it is necessary to capture
enough of the overall development of the shapes,
characteristics of the fabric and tonal range to
suggest the volume and flow of the material.

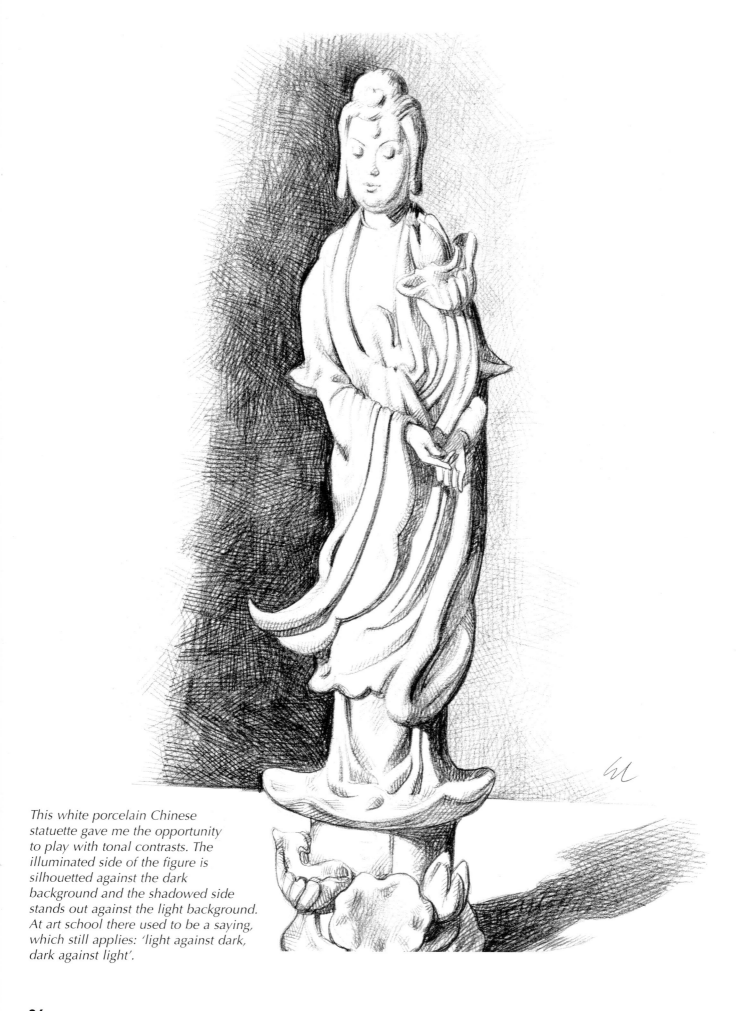

This white porcelain Chinese statuette gave me the opportunity to play with tonal contrasts. The illuminated side of the figure is silhouetted against the dark background and the shadowed side stands out against the light background. At art school there used to be a saying, which still applies: 'light against dark, dark against light'.

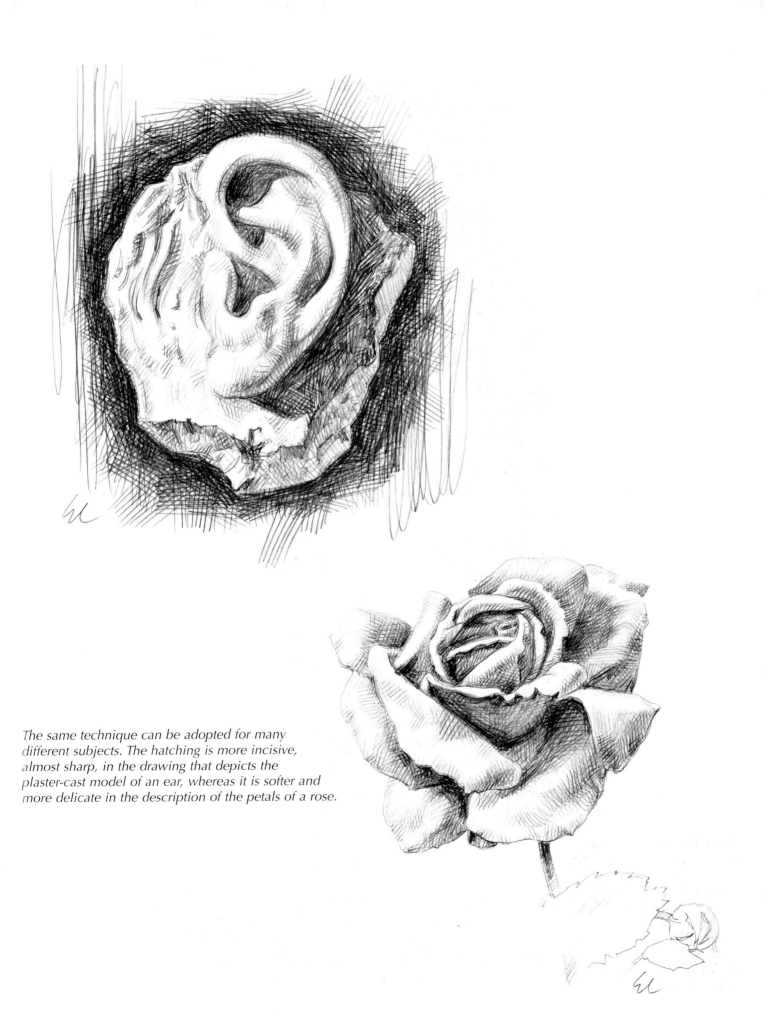

The same technique can be adopted for many different subjects. The hatching is more incisive, almost sharp, in the drawing that depicts the plaster-cast model of an ear, whereas it is softer and more delicate in the description of the petals of a rose.

TONAL KEY AND TONAL CONTRAST

In a drawing or painting the tones are based on a reciprocal relationship, i.e. they appear lighter or darker in relation to other tones, especially if adjacent. A good principle of visual perception explains, for example, that a tone appears with different intensity if placed next to another tone that is lighter or darker: an illuminated (white) area assumes greater force if surrounded by a much darker tone (see page 43). Through tonal contrasts the volume of an object becomes obvious and is more defined. Tonal key refers to the predominant relationship between the tones of a drawing or painting, in other words, to the overall degree of luminosity or darkness. Defining the tonal key and relative contrasts is a decisive factor in producing a successful work of art since it adds solid coherence to the composition and suggests an appropriate mood. For example, a high tonal key is suitable for delicate effects; a middle tonal key inspires an atmosphere of tranquillity and balance; a low tonal key creates drama.

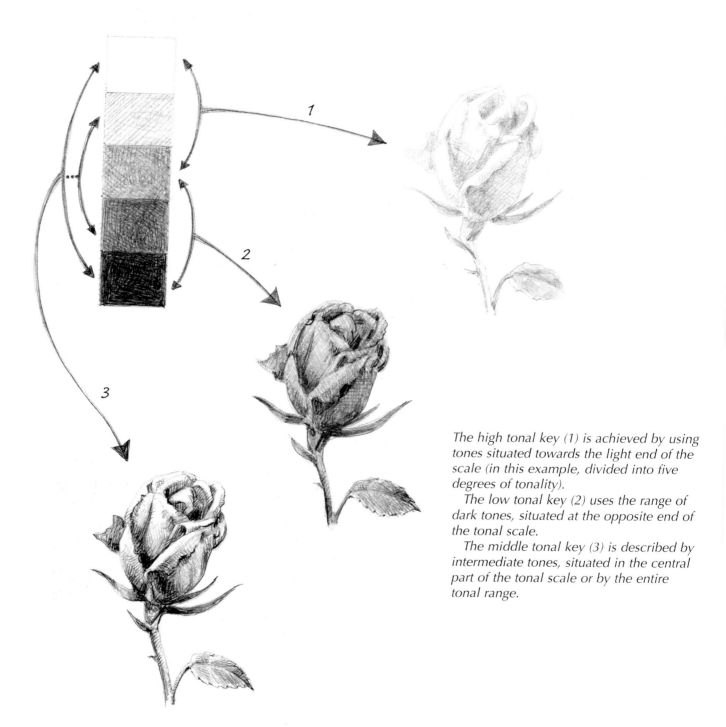

The high tonal key (1) is achieved by using tones situated towards the light end of the scale (in this example, divided into five degrees of tonality).

The low tonal key (2) uses the range of dark tones, situated at the opposite end of the tonal scale.

The middle tonal key (3) is described by intermediate tones, situated in the central part of the tonal scale or by the entire tonal range.

Tonal contrast sometimes corresponds to the tonal key, but not always. For example, a middle contrast can be associated with a middle key but a low contrast can correspond to a high key (depending on how the tones are placed) or, for the same reason, to a low key.

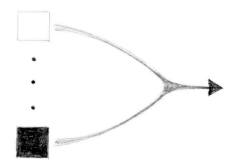

High tonal contrast (tones situated at both ends of the tonal scale).

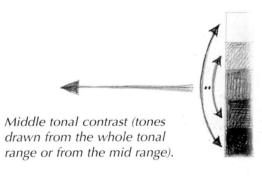

Middle tonal contrast (tones drawn from the whole tonal range or from the mid range).

Low tonal contrast (tones taken from adjacent positions, especially in the dark section of the tonal scale).

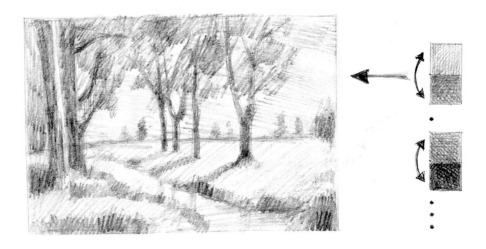

CREATING EFFECTIVE SHADING

There are various ways of producing a good chiaroscuro work, especially in relation to the graphic tools (graphite, charcoal, etc.) or pictorial tools (oil, tempera, etc.) chosen by the artist but, for all these, it is possible to single out a common method, useful for acquiring or sharpening powers of observation and tonal technique.

1 – carefully observe the object, capture the overall proportion, tone and form; 2 – draw, with light strokes that are close together, the main shadows; avoid adding areas of tone that are too uniform or have vague boundaries, identify the darkest and lightest areas only; 3 – add the main tonal gradations observed on the object and in relation to the environment; 4 – the lightest ones are produced, usually, with clean white paper and you can outline them with a slightly darker area, so as to make them stand out more; 5 – evaluate the development and success of the chiaroscuro by observing the object and the drawing with half-closed eyes; 6 – refine the tones and tonal values until you obtain the appropriate intensity and the right relationship between them; evaluate the correctness (on the object, on the drawing and in relation to the environment) of the contrasts and accents.

In a good chiaroscuro work (remembering always that it is about an exercise in observation, and not necessarily about works of art) the shadows must be decisive, quite sharp but not hard, with a certain transparency and able to suggest the development of the planes. Tonal changes should be soft, although firm and well defined, and the points of maximum luminosity situated in the right position, produced with decision and with a coherent, meaningful effect.

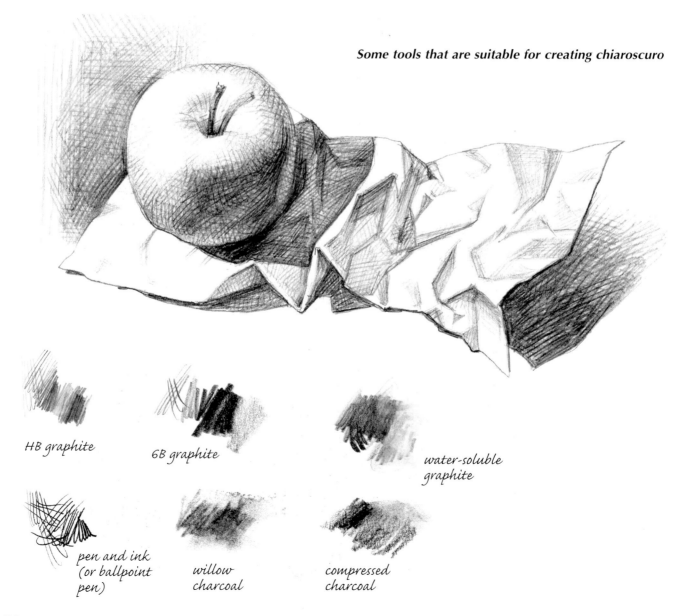

Some tools that are suitable for creating chiaroscuro

HB graphite

6B graphite

water-soluble graphite

pen and ink (or ballpoint pen)

willow charcoal

compressed charcoal

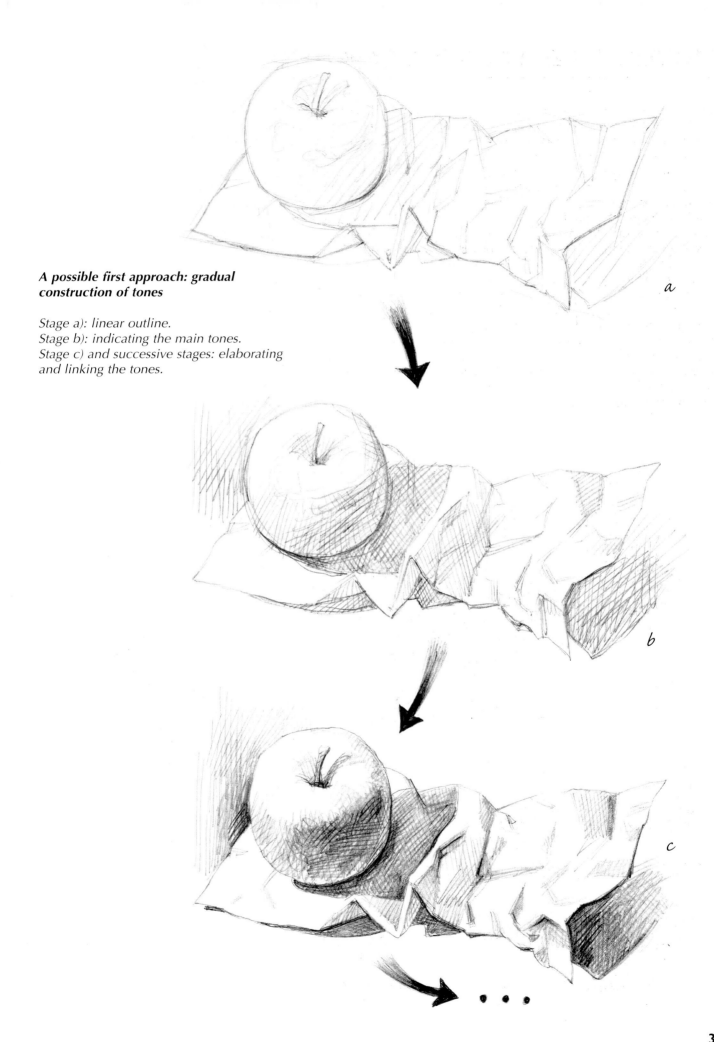

A possible first approach: gradual construction of tones

Stage a): linear outline.
Stage b): indicating the main tones.
Stage c) and successive stages: elaborating and linking the tones.

a

b

c

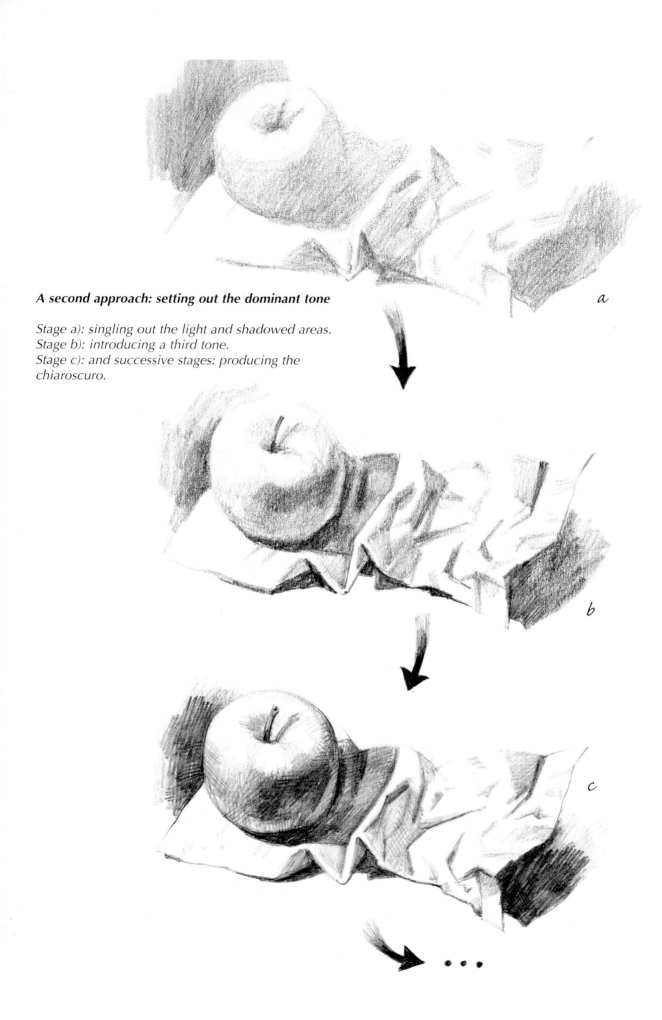

A second approach: setting out the dominant tone

Stage a): singling out the light and shadowed areas.
Stage b): introducing a third tone.
Stage c): and successive stages: producing the chiaroscuro.

a

b

c

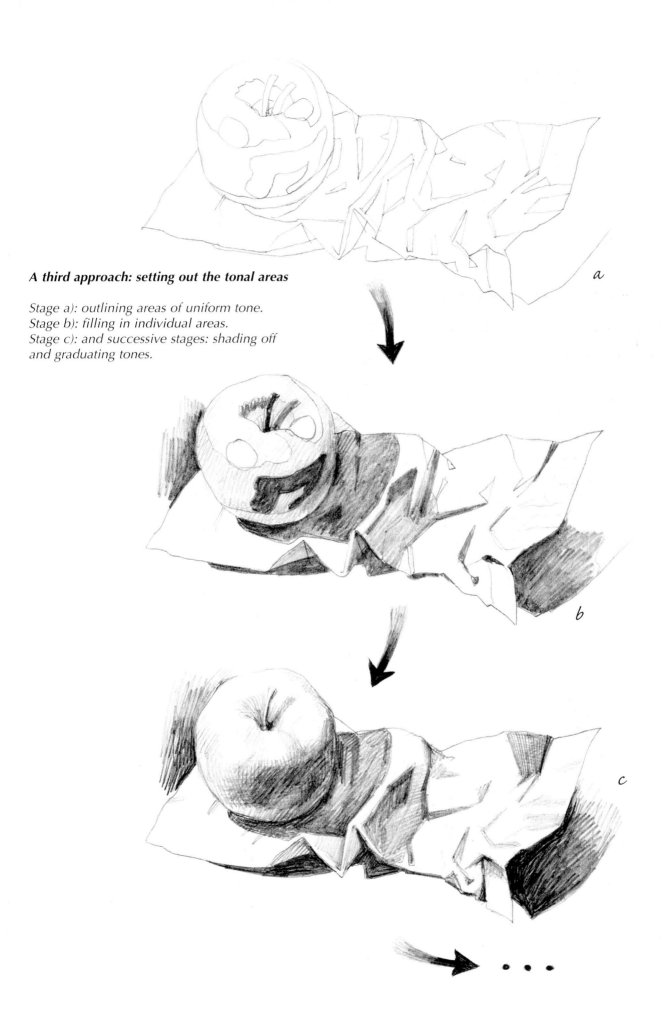

A third approach: setting out the tonal areas

Stage a): outlining areas of uniform tone.
Stage b): filling in individual areas.
Stage c): and successive stages: shading off
and graduating tones.

a

b

c

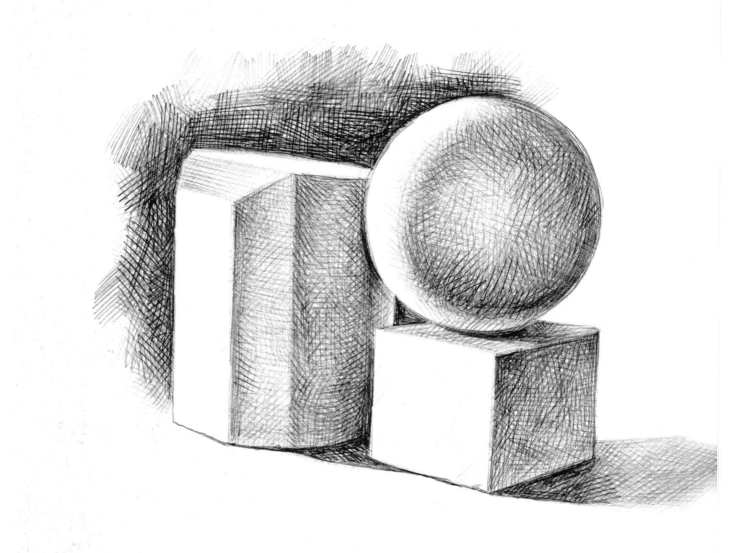

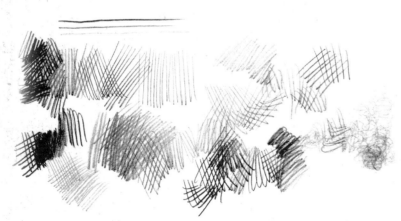

Study of shadows on plaster cast geometric solids

1 – 0.5 HB micro lead
A very fine graphite lead allows you to produce a wide range of tones by simply crossing the strokes more or less densely. Take care to leave some transparency and light in the more intense shadows as well.

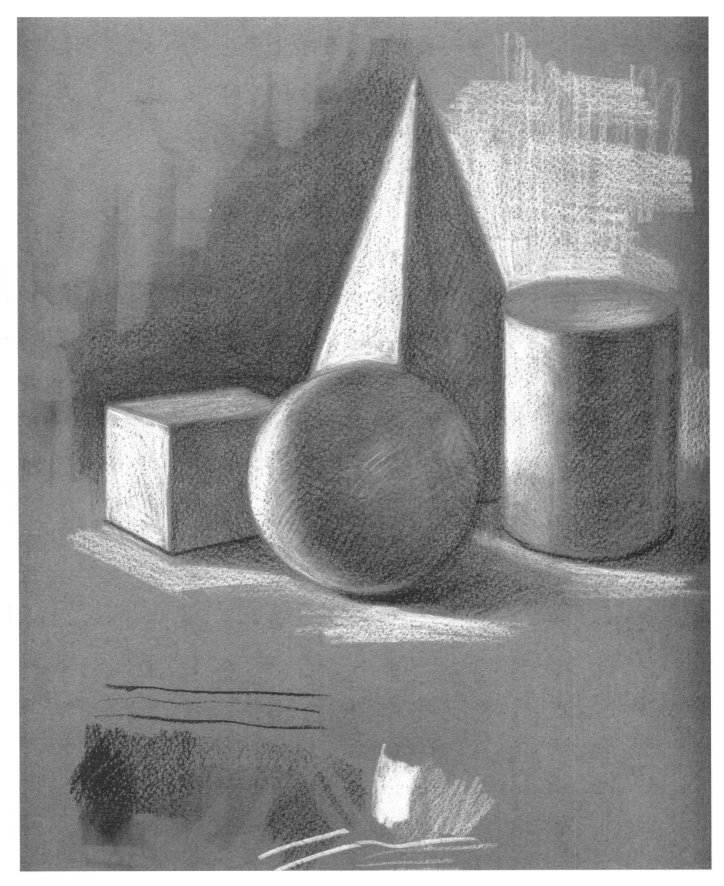

2 – Black compressed charcoal and white gesso, on coloured paper
The use of coloured paper of a moderately dark tonality allows you to depict objects
merely by indicating the darker tones of shade and the lighter areas, illuminated by the
light. The intermediate tone is indicated by the medium itself.

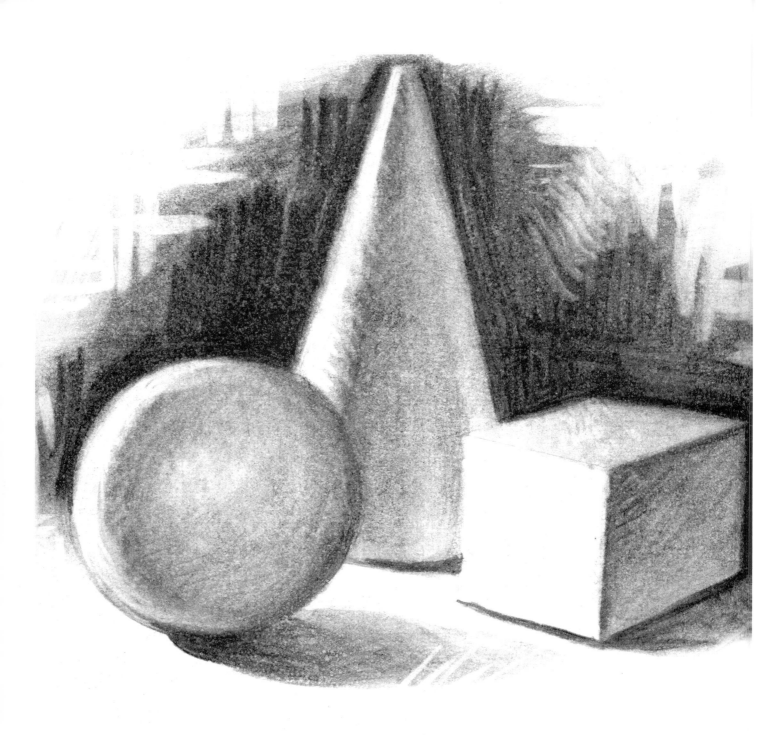

3 – Willow charcoal
The 'willow stick' (obtained by charring small willow twigs) offers a very wide range of greys. Gradation can be achieved by shading off with your finger or a piece of soft cloth. The illuminated areas are emphasised by lightening or removing the charcoal strokes with a kneadable putty rubber.

4 – Compressed charcoal

Unlike willow charcoal, compressed charcoal produces very intense dark tones and presents some major difficulties in obtaining the more delicate gradation of light tones. In darker areas it is advisable to avoid a too uniform and compact thickening of tone by, instead, using a slightly graduated hatching.

Similar in use to the black compressed charcoal is 'sanguine', a warm, delicate, reddish-brown chalk, very suitable for nude and portrait studies.

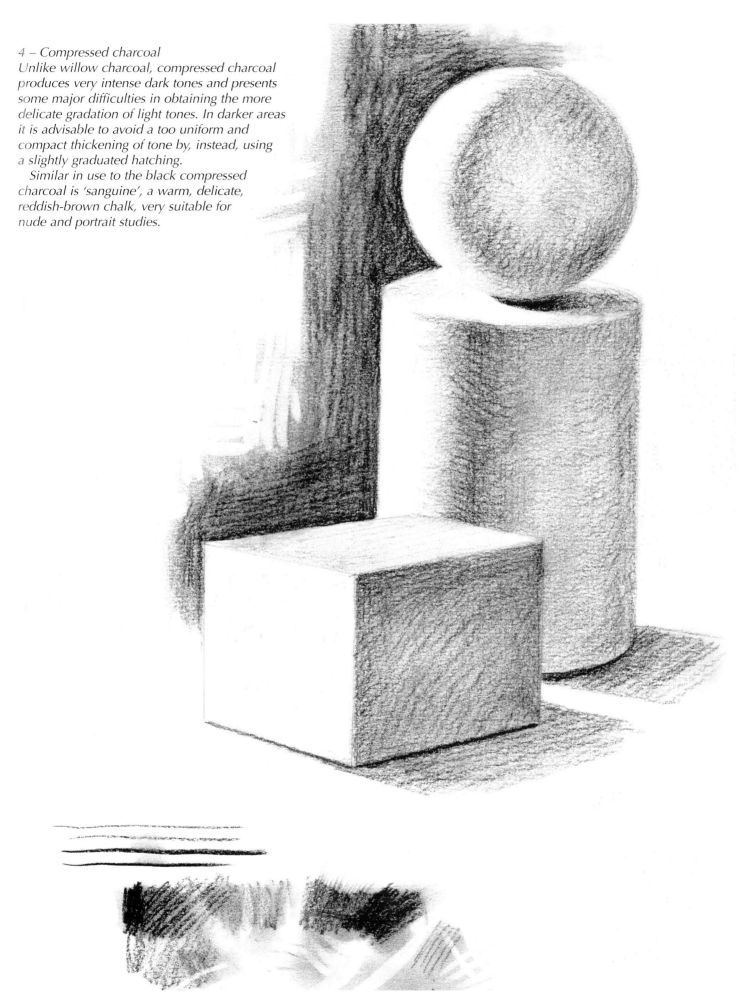

On the following pages (pages 38–45), you will find some black and white photographs of plaster casts and simple natural elements. They are useful for doing some preliminary exercises in chiaroscuro technique before approaching the study of similar subjects directly from life. The 'copy from plaster cast' method has always been considered a tedious and, nowadays, out-of-date and scholastic practice. And yet, it is fundamental for learning the technique element of drawing, and carefully and calmly analysing the chiaroscuro effects produced by the various objects and different angles of lighting. The white, uniform surface of the plaster cast enables us to single out the more delicate tonal changes and provides the opportunity to observe them very accurately, reproducing them without the complications of colours or movements.

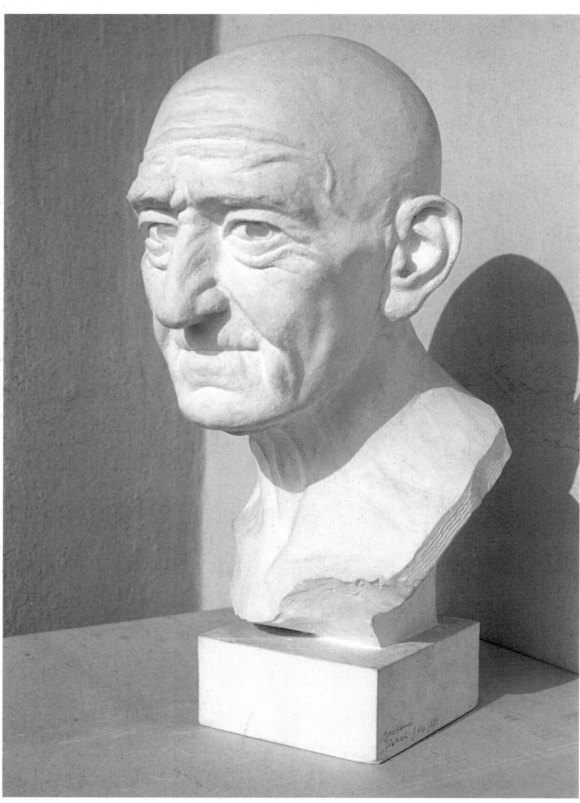

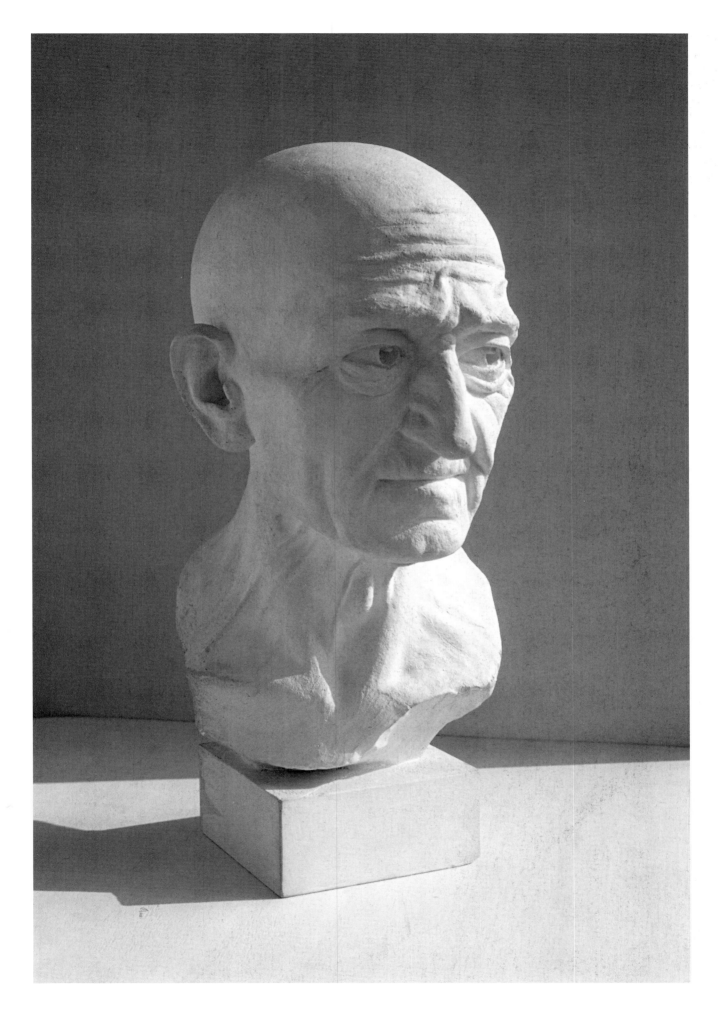

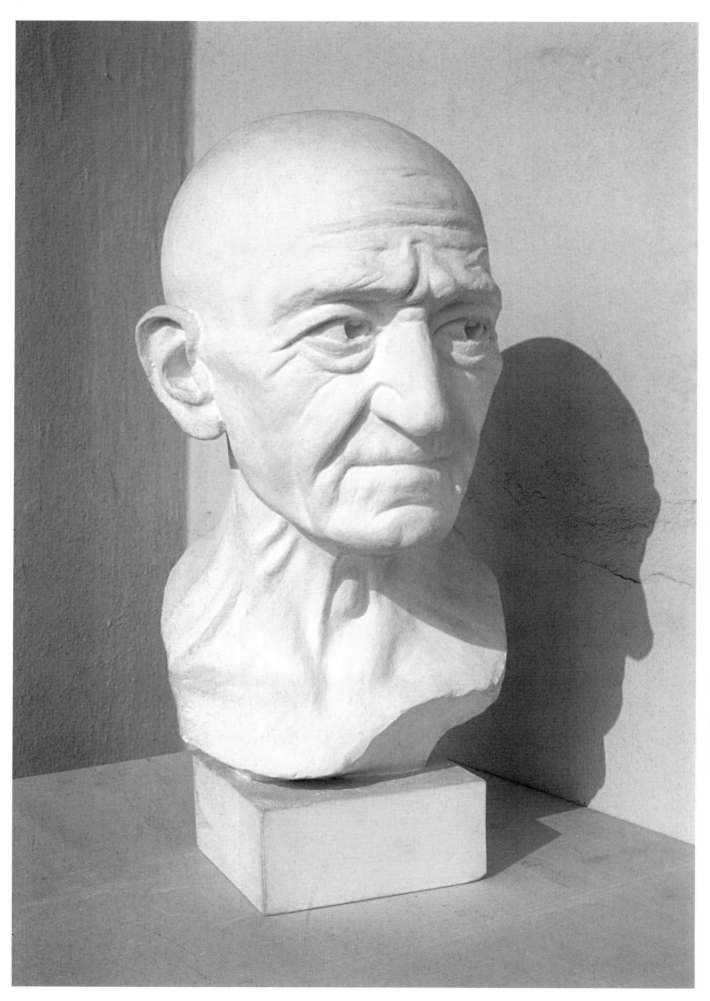

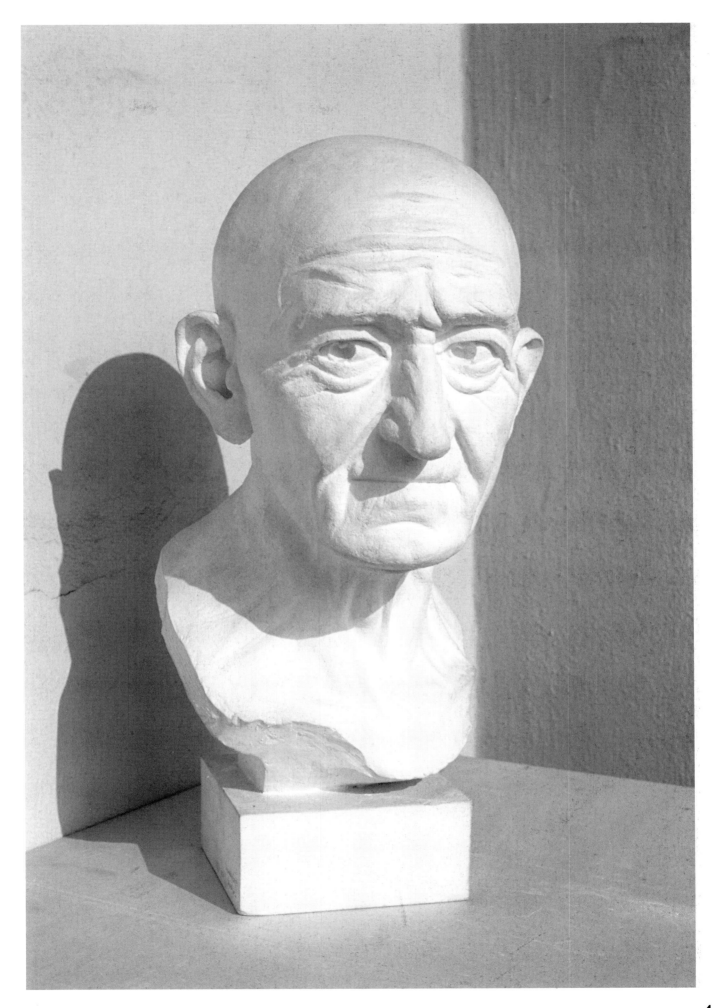

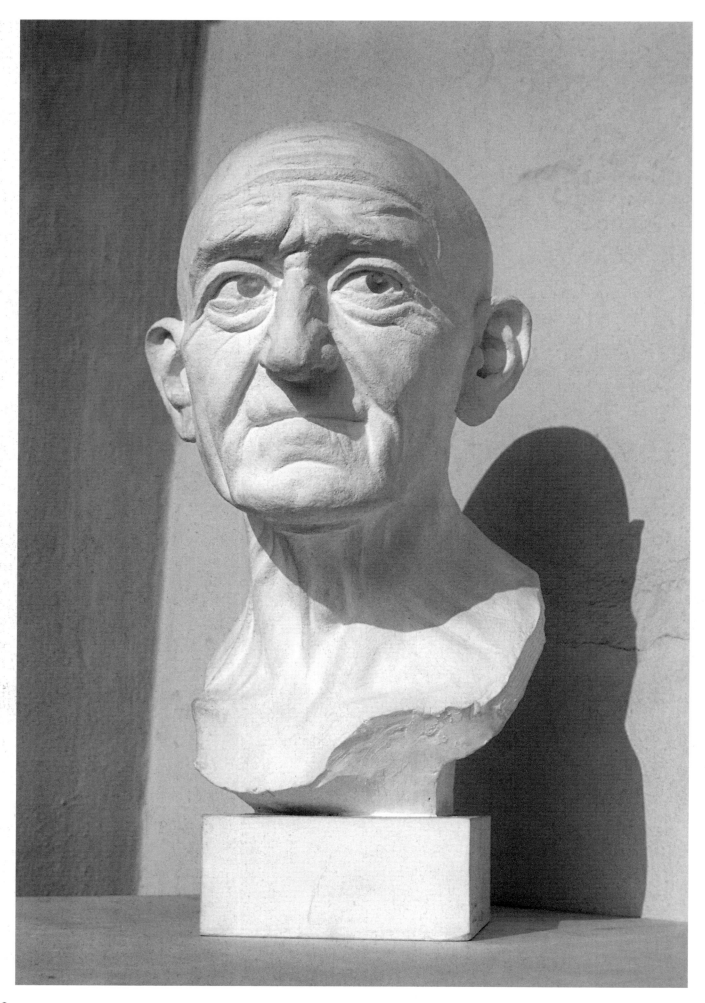

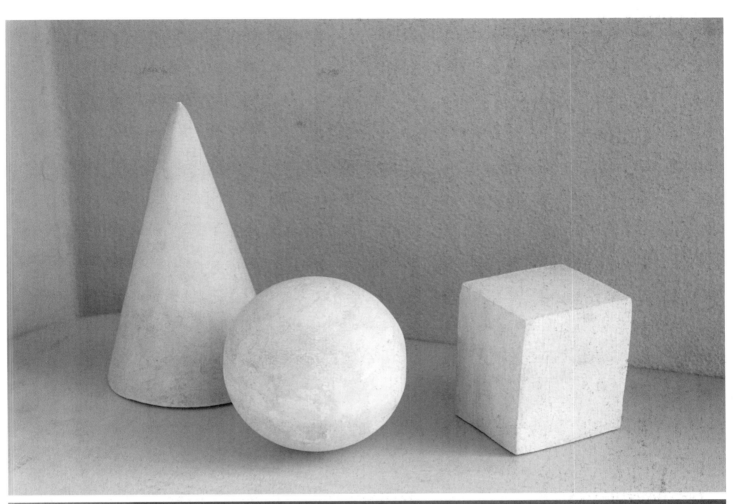

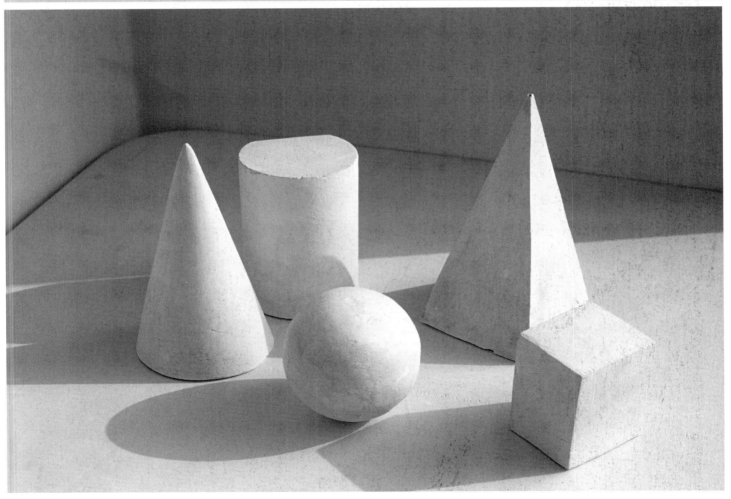

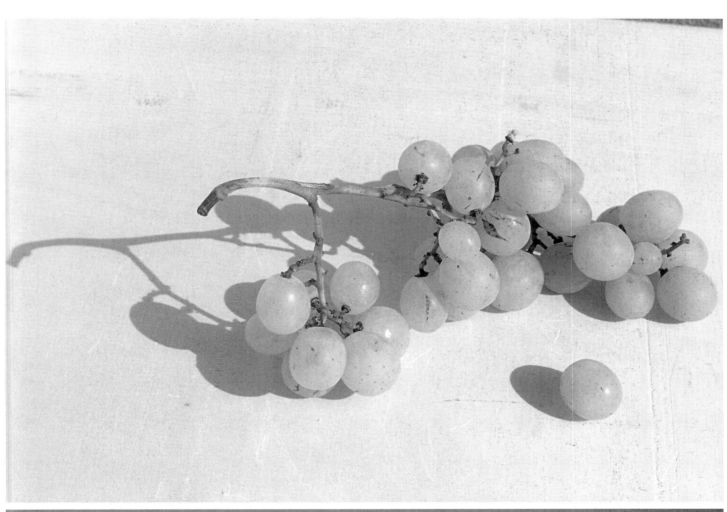

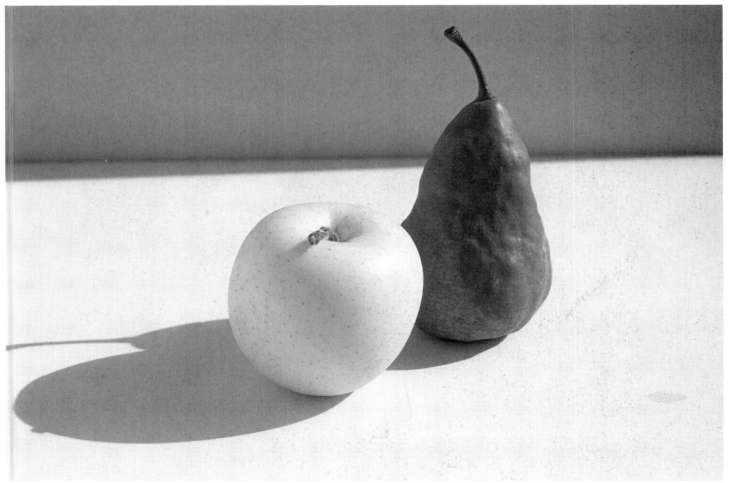

COMPOSITION

Tonal structure – the way in which the light and dark areas are organised and the contrasts that derive from them – constitutes an important aspect of the composition of a painting or drawing. Composition is, in fact, the arrangement of the various elements of a picture to create a coherent and meaningful whole. In composition we try to find the most suitable solution for organising the layout of the forms and tones, according to the principles of balance or unbalance, symmetry or asymmetry, inactivity, or dynamism and tension. These principles are not exact and binding rules but are, rather, generally the result of artistic experience and aesthetic reflection on partly instinctive observation.

Analysing the works of artists who have made use of chiaroscuro to compose their pictorial works, in various periods and various styles, is particularly useful.

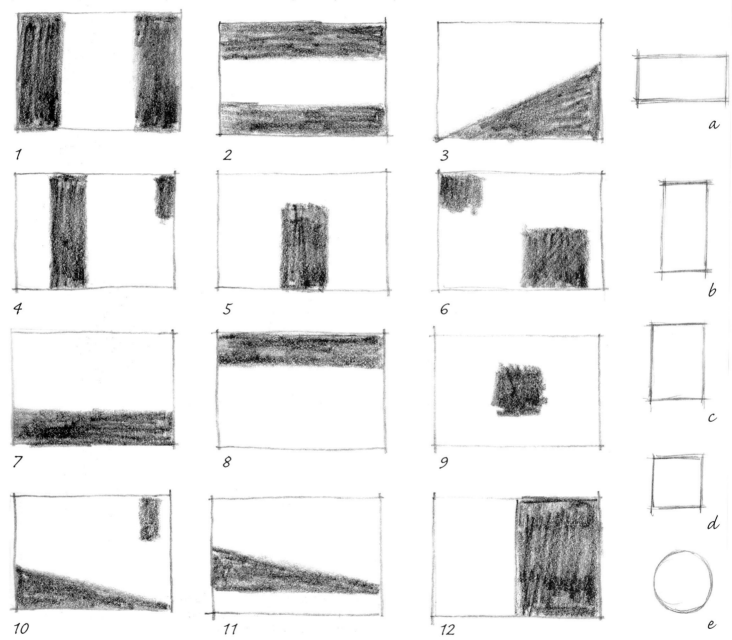

The format of the medium (a–e), which is traditionally rectangular (more rarely square or round), suggests the way in which to arrange the elements of the picture – the composition – in relation to the expressive meaning you wish to give it. This can, depending on how it is organised, arouse different feelings; balance/symmetry (sketches 1, 5, 9, 12); unbalance/asymmetry (1, 3, 4, 6); weight/gravity (7, 8); inactivity (5, 7, 9); dynamism/tension (3, 10, 11).

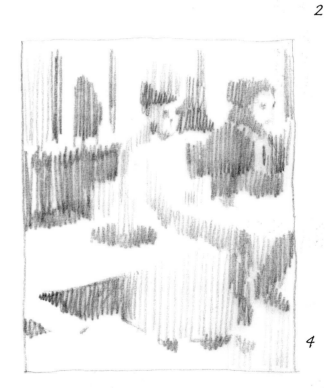

1

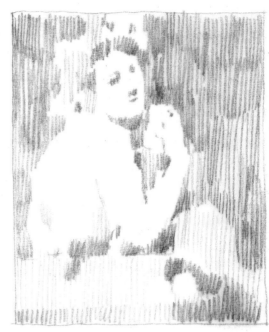

2

3

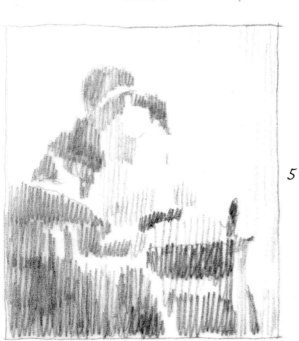

5

4

Tonal sketches taken from famous paintings: this is a very effective exercise for improving your ability to compose pictures including the use of chiaroscuro.

1. *John Singer Sargent* Portrait of R.L. Stevenson *(1887)*
2. *Michelangelo Merisi da Caravaggio* Sick Bacchus *(1593)*
3. *Edgar Degas* The Tub *(1885)*
4. *Edgar Degas* The Absinthe Drinker *(1876)*
5. *Johannes Vermeer* The Lacemaker *(1664)*

VOLUME AND RELIEF

The quality (direct or diffused, intense or weak) and type (natural or artificial) of light determine the aesthetic result of the picture. Varying the light can also vary, sometimes in a surprising way, the appearance of the shapes. They may stand out or the finer features of the surface disappear.

The light, in fact, emphasises the relief of whatever it is illuminating and gives the feeling of volume, space and atmosphere. Sculpture and architecture are also affected by light; form being influenced by whether light directly hits or barely touches the surfaces and shapes, creating sharp or soft, intense or weak shadows and creating the subtlest variations of chiaroscuro.

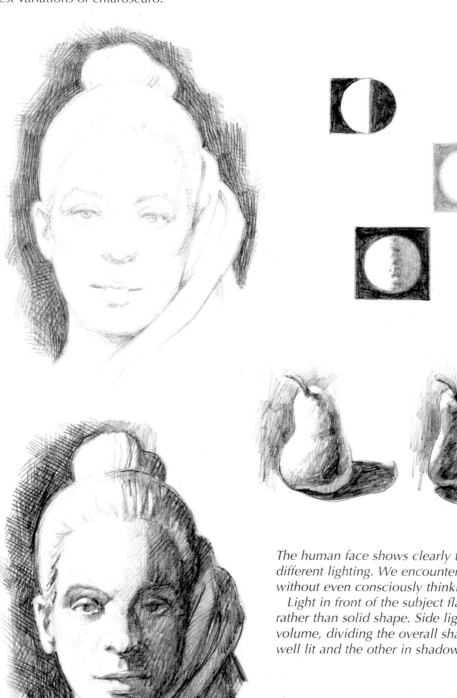

The human face shows clearly the various expressive effects of different lighting. We encounter these images on a daily basis, perhaps without even consciously thinking about them.

Light in front of the subject flattens the relief and suggests a flat, rather than solid shape. Side lighting, on the other hand, highlights the volume, dividing the overall shape into two halves, one of which is well lit and the other in shadow.

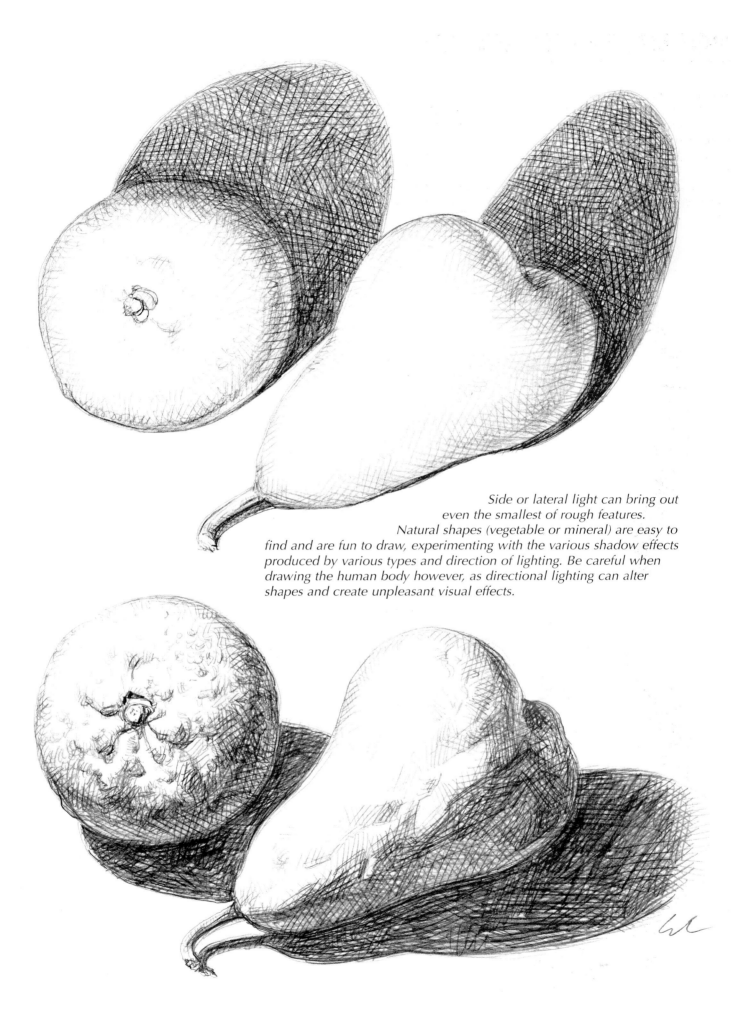

Side or lateral light can bring out even the smallest of rough features.

Natural shapes (vegetable or mineral) are easy to find and are fun to draw, experimenting with the various shadow effects produced by various types and direction of lighting. Be careful when drawing the human body however, as directional lighting can alter shapes and create unpleasant visual effects.

AERIAL PERSPECTIVE

Aerial perspective considers the effects of tonal gradation produced by distance. When creating landscape pictures, for example, the objects in the foreground (nearest the observer) are very sharp and the tones and colours more intense. In the middle and background, however, these characteristics gradually fade away, are toned down and become hazy. Graduating the tones – from intense in the foreground to soft in the distance – effectively suggests the feeling of depth and the recession of space.

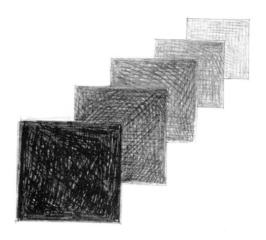

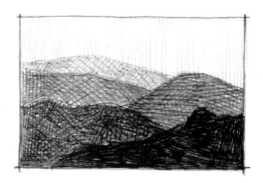

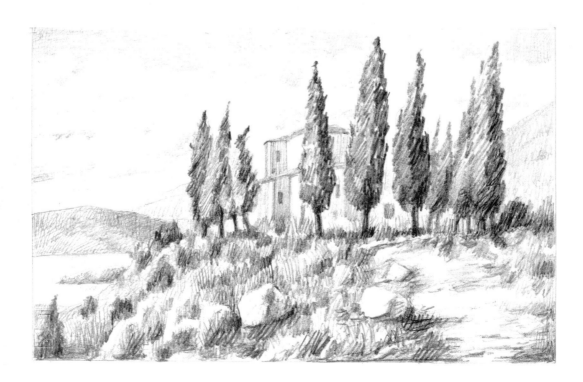

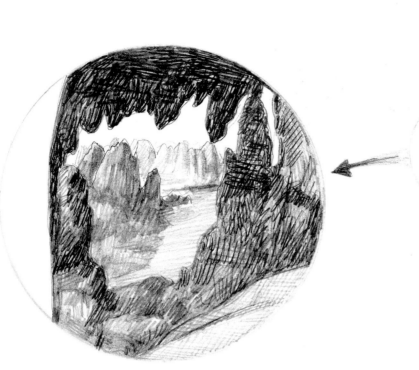

Tonal sketch from The Virgin of the Rocks *(London, National Gallery) by Leonardo da Vinci.*

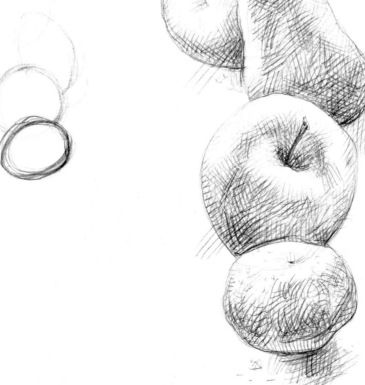

Pictorial examples of aerial perspective are innumerable and a good way to study (by drawing schematic tonal sketches) the effects obtained by the greatest Western artists, from the Renaissance to the Impressionists.

At short distances (in still life or figure drawing, for example) the effect of aerial perspective is, of course, very modest. You can suggest the feeling of depth by accurately and sharply outlining the elements that are nearest to the viewer and by using softer tones to outline objects or parts that are a bit further away. Another important device is to partially overlap the shapes, so that they form a sort of visual connection as they recede.

EFFECTS OF CHIAROSCURO IN ART

The use of chiaroscuro in art has always existed, to some extent, but it came to the fore during the Italian Renaissance and rapidly spread to the whole of Western art, including contemporary art. Various periods and cultures have made different use of chiaroscuro, attributing it with a variety of characters: for example, highly expressive and dramatic (Caravaggio), or a profound existential experience (Rembrandt), or a glance at intimate, suspended life (Vermeer), or, again, the brightness of the sun in nature and a luminous atmosphere (Monet). Examples of it and its decline in importance are, of course, innumerable. It can be a good exercise to examine some artists' works from various periods and in various styles, making tonal and compositional studies of them (if possible, taken from works directly observed in galleries).

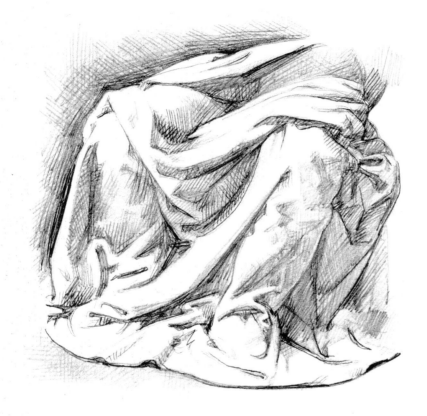

Leonardo da Vinci Study of Drapery *(circa 1478)*

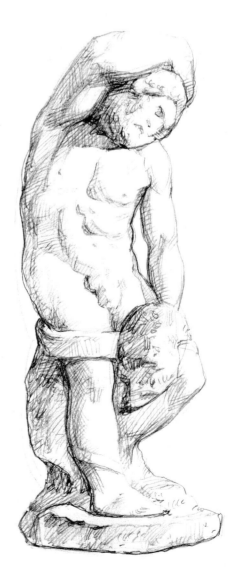

Michelangelo Buonarroti Slave (Atlas) *(1519)*

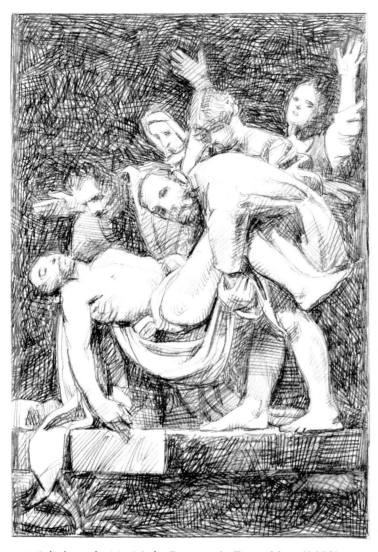

Michelangelo Merisi da Caravaggio Deposition *(1602)*

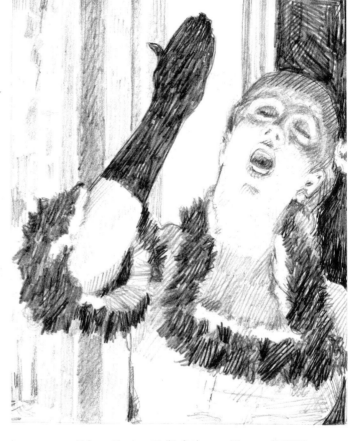

Edgar Degas Café Concert Singer *(1878)*

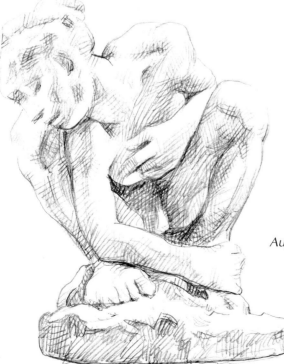

Auguste Rodin Crouching Woman *(1882)*

STUDIES FROM LIFE

It seems appropriate to present here a small collection of my drawings, produced with various techniques at different times during my artistic career. The aim is not to exhibit my own work or propose examples to copy. Anything but. These works should suggest a variety of means and topics with which you can practise observing chiaroscuro and, above all, encourage you to find and follow your own means of expression: find (through careful study of the natural) the most personal and appropriate ways of freely expressing your true personality, emotions and investigative curiosity.

Drawing, with its technical skills learnt well, is the most complete and thorough tool for seeing and knowing the world around us and those who inhabit it, and for expressing the emotions that all this arouses in us.

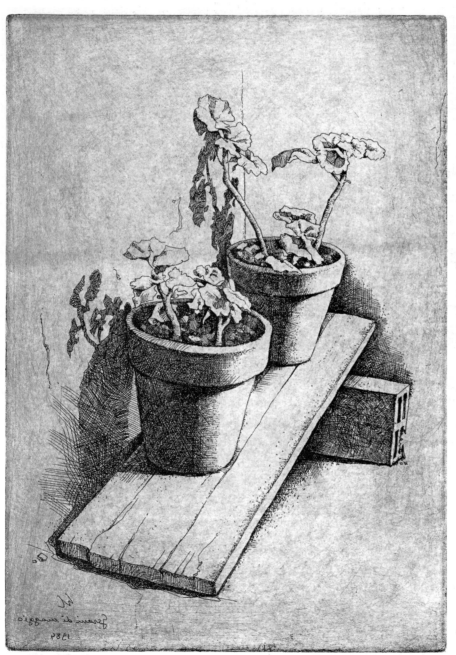

Geraniums
Etching, 15.7 x 21.6cm (6 x 8¹/₂in)

I have included several etchings in this section, a copper-engraving technique where the cross-hatching is of fundamental importance for depicting the appropriate chiaroscuro values. Careful observation of etchings can suggest similar results that can be achieved in pencil or pen and ink.

This small study portrays a pair of pots with flowers in my garden, sloping away from each other in a precarious position: perhaps a poor subject, but a pretext for focusing on the almost abstract play of light and shade.

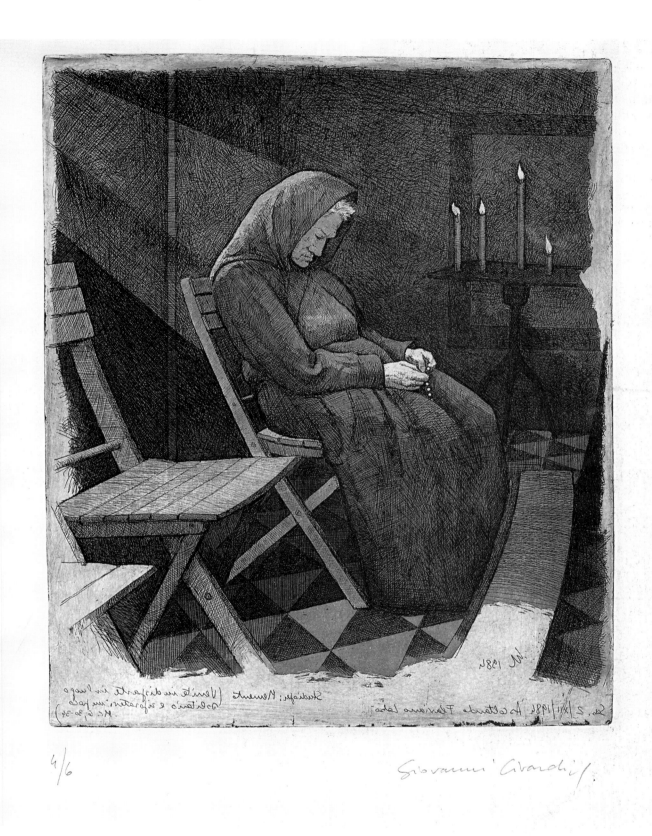

4/6

Giovanni Civardi

Rosina in Caravaggio's Sanctuary
Etching and acquatint, 21.4 x 26.4cm (8¹/₂ x 10in)

Even a very dark environment presents many tonal shifts. In this case, the intense light coming from a small window 'sculpts' everything it touches and depicts its volume. It is best not to accentuate the contrasts in tone too much and study, instead, the subtle modulations; on the praying figure's face and hands and on the floor, around the candles for example.

 In etching, the final print inverts the original image drawn on copper and this should be born in mind in the composition and in any written notes.

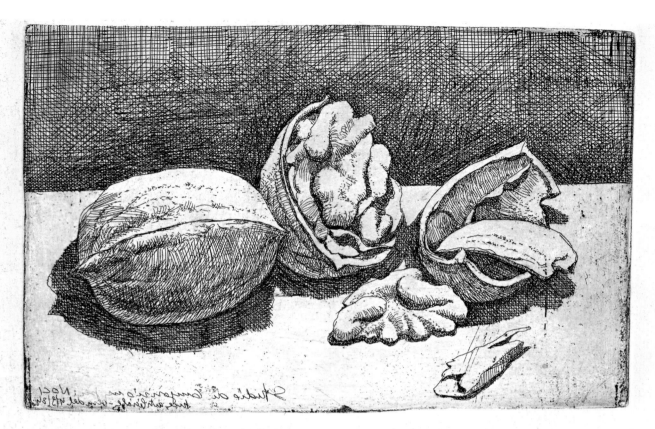

1/5

Giovanni Civardi

Shells and Kernel: Fragments
Etching, 16 x 10.5cm (6 x 4in)

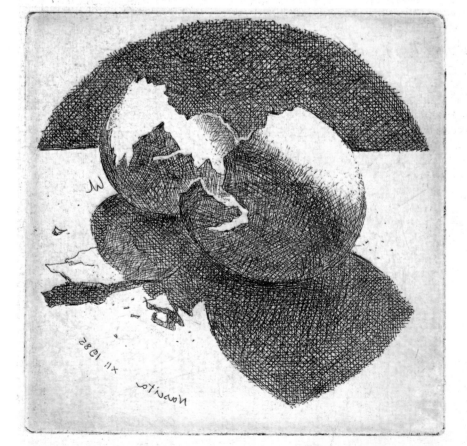

Birth
Etching, 6.5 x 6.8cm (2$\frac{1}{2}$ x 2$\frac{3}{4}$in)

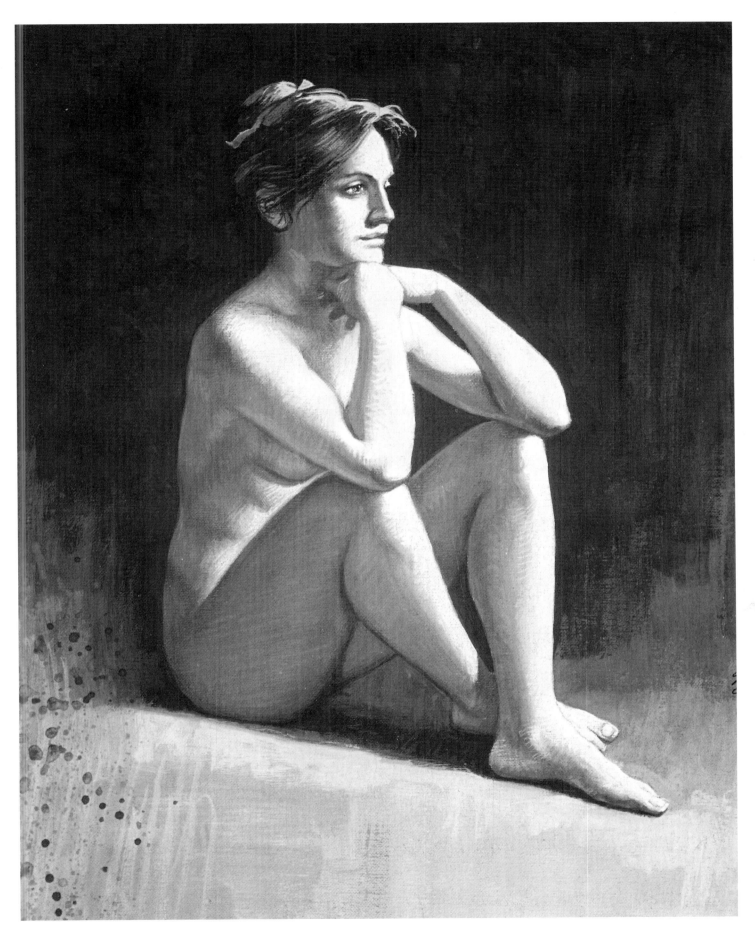

Elsa's Wait
Tempera on canvas board, 30 x 40cm (11³/₄ x 15¹/₂in)

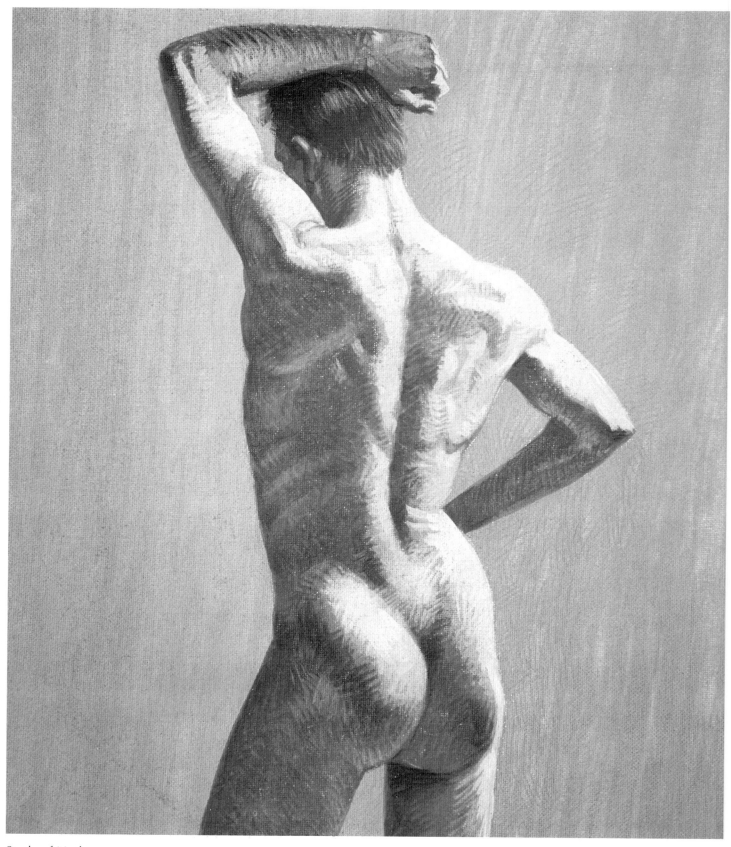

Study of Nude
Tempera on canvas board, 25 x 35cm (10 x 13³/₄in)

Lateral lighting is suitable for emphasising the anatomical details and muscular play of the human figure. However, do not overdo the chiaroscuro or use a skimming light, as the effect can be distorting and even unpleasant. Light reflected by the environment, however, is useful for indicating the body structure accurately and with a sense of volume.

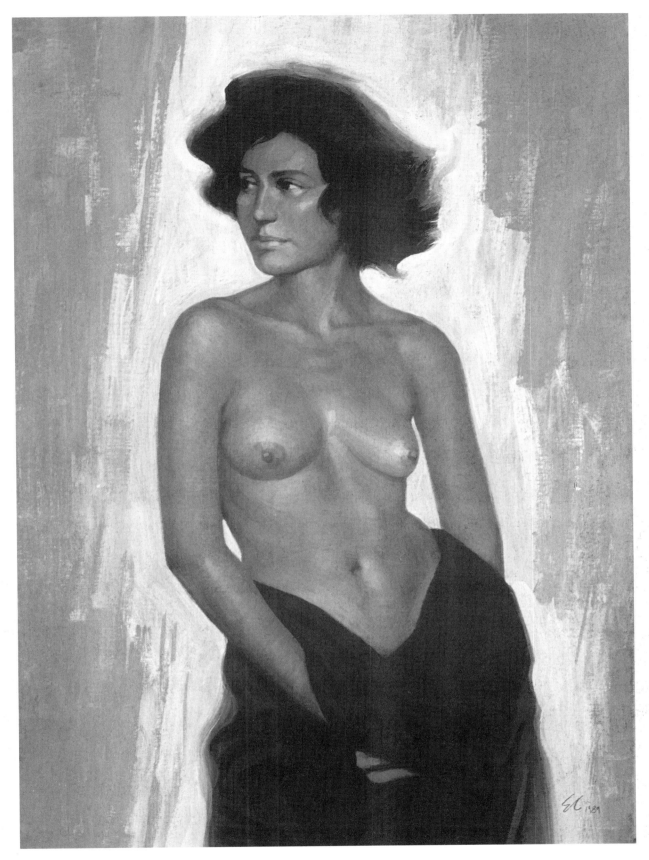

Portrait of Miriam
Oil on canvas board, 35 x 50cm (13³/₄ x 19¹/₂in)

*Using oil diluted with plenty of turpentine creates an opaque colour similar to tempera,
and with this you can obtain very delicate tonal changes, suitable for depicting the softness
of the parts of the body on this nude, illuminated by a frontal light that is diffused.*

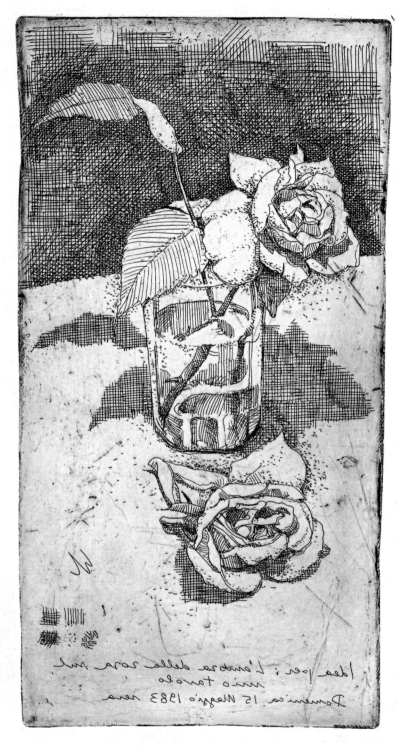

1/8 Giovanni Civardi /.

The Shadow of the Rose on my Table
Etching, 9.5 x 19.5cm (3³/4 x 7¹/2in)

A rose lit from above with a single electric light bulb produces a very definite chiaroscuro effect with few intermediate tones. The visual weight of the dark background is in the upper part of the drawing, but is balanced by the vertical arrangement of the two roses and the shadow that one of them casts on the table.

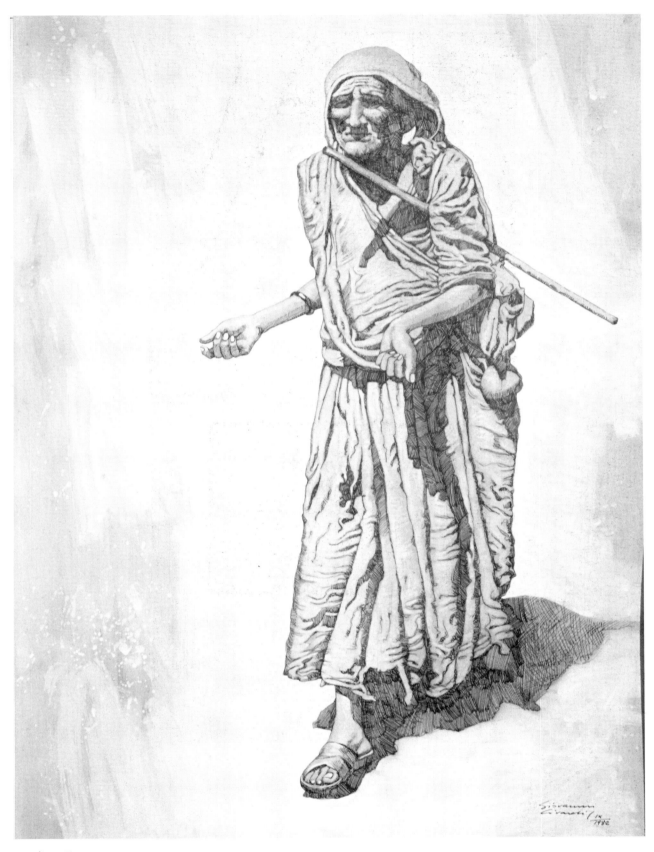

Bikaner: Indian Figure
Pen, China ink, white tempera, yellow ochre acrylic, 50 x 70cm (19¹/₂ x 27in)

This drawing was done on my return from a trip to India, relying on memory and also on photographs and sketches made from life. The play of intense shadows establishes a 'nervous' and lively chiaroscuro, in harmony with the tormented aspect and character of the figure portrayed. The shadows cast by the stick and left arm are useful for giving the feeling of protrusion of these two elements.

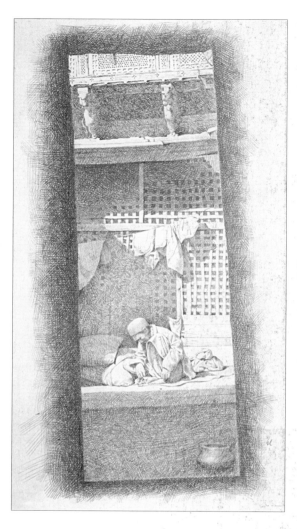

Fragments of Ancient Times
H graphite on cardboard, 36 x 51cm (14 x 20in)

This preparatory study for a book illustration is an excellent example of tonal contrast (see page 28). The play of chiaroscuro between the inlaid work on the building, the overlapping floors and the depth of the setting almost cancels out the crouching figure that is broken down into tonal fragments. In reality the intense sunlight created sharp shadows but the deep darkness of the porch from which the scene is viewed renders them rather pale.

From the
Traveller's Notebook (Visual diary, series 2, no. 2)
0.5 HB graphite, double page 14 x 18cm (51 x 7in)

The true artist is always alert: everything that happens around you or springs to mind can be the object of a work or, at least, a sketch or a simple explorative drawing. I keep a small visual diary – I use pocket-sized notebooks – that I gradually fill with notes of images, thoughts and emotions. This is good practice for all artists. You will realise, then, that chiaroscuro is found everywhere, but drawing it from life can lead to discovering aspects that are unexpected.

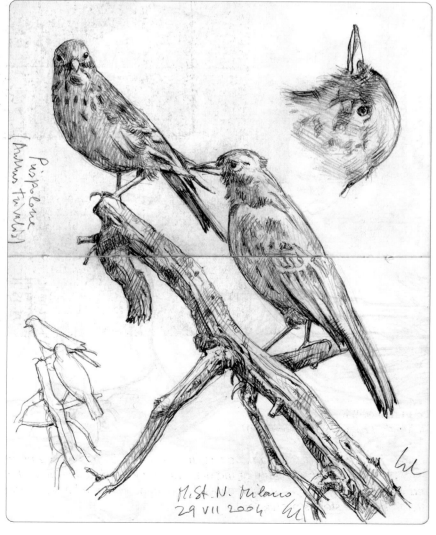

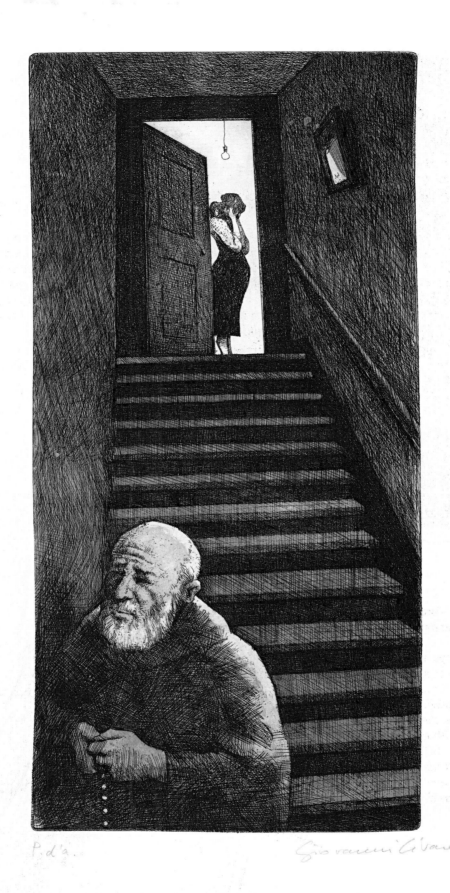

Mysteries of Life
Etching, 14.8 x 30.3cm (6x 12in)

This is an illustration for a dramatic tale, in which a sad and moving human situation is described. The gloomy tonality of the drawing is lifted by subtle tonal changes on the stairs and walls that enclose it, whilst the passage of light from the half-open door draws your attention to the story's protagonist.

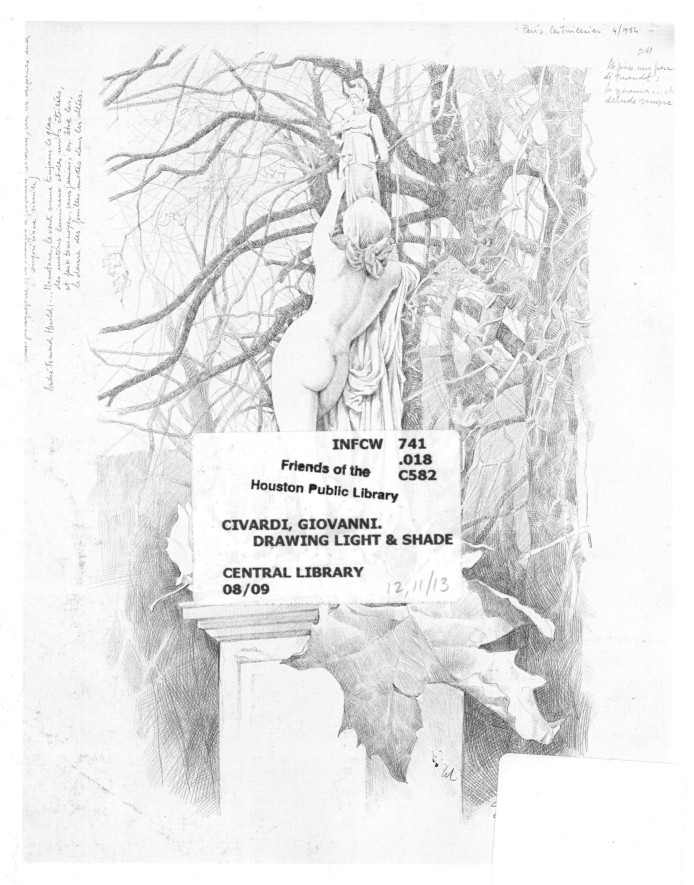

Leaves (Paris, Les Tuileries): Homage to Boldini
H, HB graphite on paper, 42 x 55cm (16¹/₂ x 21¹/₂in)

*Chiaroscuro does not necessarily have to be associated with intense tones of shade.
This drawing shows a fine and delicate central structure that is nevertheless rich in
tonal changes, and chiaroscuro is used to create a misty, autumnal atmosphere.*